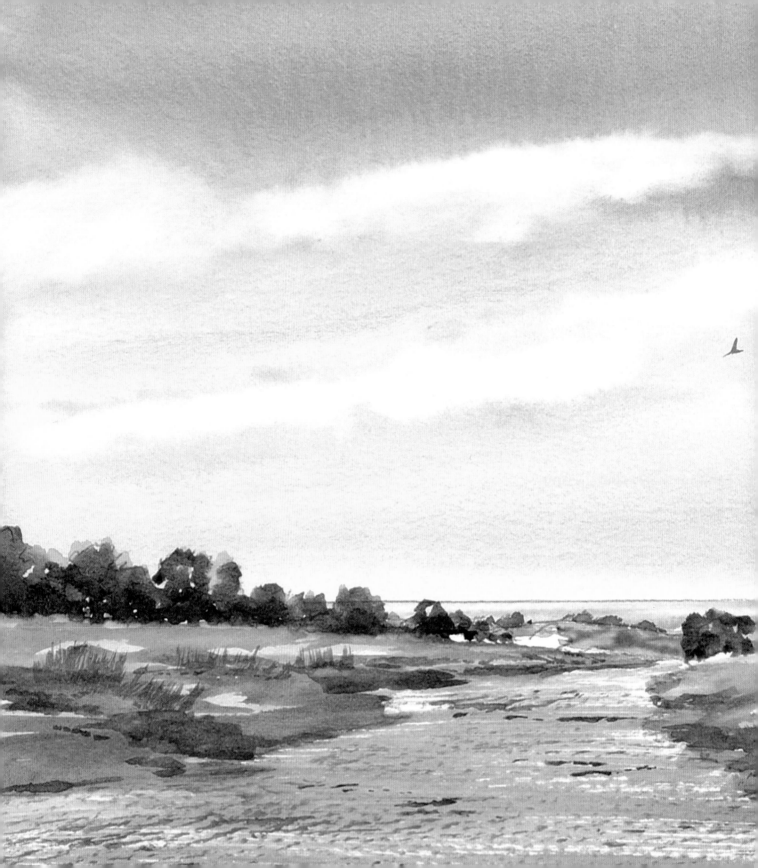

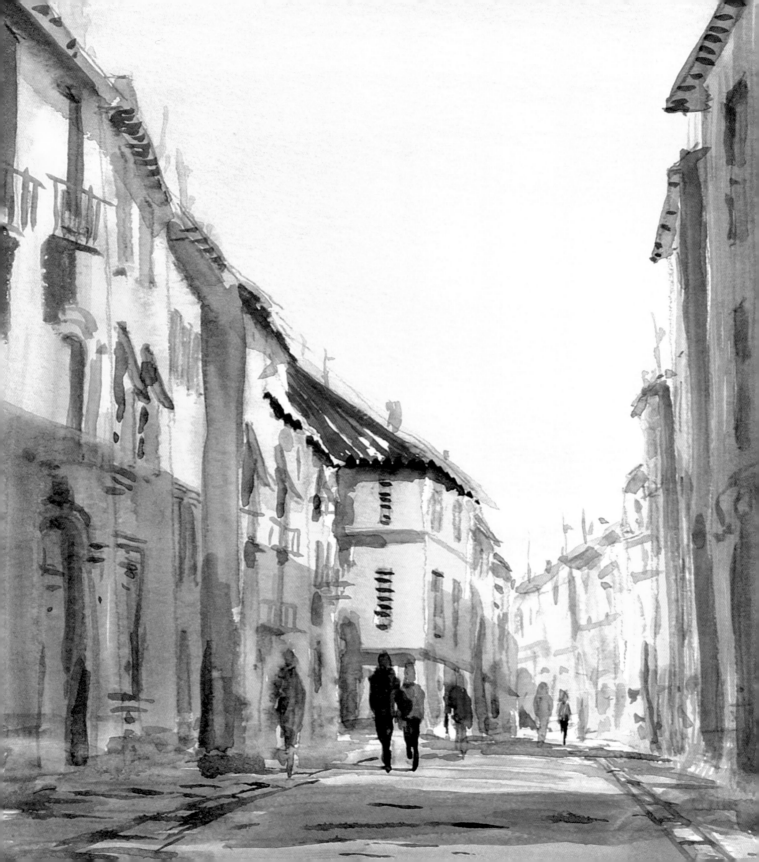

CHARLES EVANS'

watercolours in a weekend

D&C
David and Charles

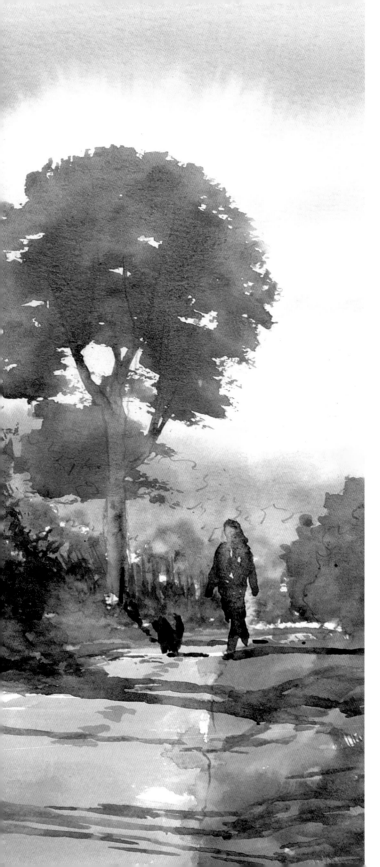

This book is dedicated to Margaret and Ken – without their dedication, the many courses I do from home wouldn't run, the catering wouldn't be so lovely, and I wouldn't be organized enough to get myself out on the road with clean washing every trip. Thank you so much for all your hard work.

A DAVID & CHARLES BOOK
Copyright © David & Charles Limited 2007

David & Charles is an F+W Publications Inc. company
4700 East Galbraith Road
Cincinnati, OH 45236

First published in the UK in 2007
First US paperback edition 2007

Text and illustrations copyright © Charles Evans 2007

Charles Evans has asserted his right to be identified as author of this work in accordance with the Copyright, Designs and Patents Act, 1988.

A catalogue record for this book is available from the British Library.

ISBN-13: 978-0-7153-2467-7 hardback
ISBN-10: 0-7153-2467-5 hardback

ISBN-13: 978-0-7153-2468-4 paperback (USA only)
ISBN-10: 0-7153-2468-3 paperback (USA only)

Printed in China by ShenZhen Donnelley Printing Co Ltd.
for David & Charles
Brunel House Newton Abbot Devon

Commissioning Editor Freya Dangerfield
Assistant Editor Louise Clark
Project Editor Ian Kearey
Art Editor Sarah Underhill
Design Assistant Emma Sandquest
Production Controller Kelly Smith
Photographer Karl Adamson

Visit our website at www.davidandcharles.co.uk

David & Charles books are available from all good bookshops; alternatively you can contact our Orderline on 0870 9908222 or write to us at FREEPOST EX2 110, D&C Direct, Newton Abbot, TQ12 4ZZ (no stamp required UK only); US customers call 800-289-0963 and Canadian customers call 800-840-5220.

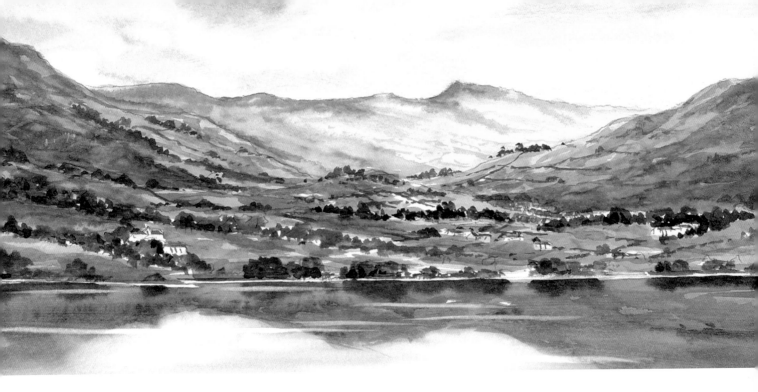

CONTENTS

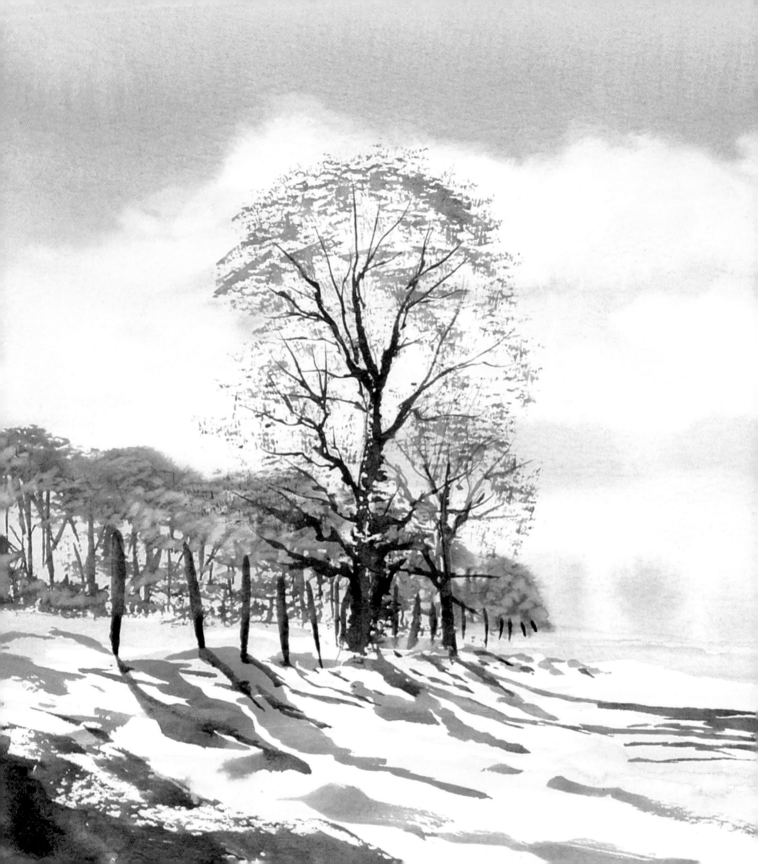

INTRODUCTION

This book aims to demystify some aspects of working with watercolours, and to make painting less scary and more user-friendly.

Beginning with a brief guide to basic materials and techniques, everything has been designed for the weekend artist: by following the Saturday exercises you'll soon learn some of the so-called 'intricacies' of watercolours, and then you can use these techniques in each of the Sunday projects to produce some finished paintings you can be proud of.

Hopefully, along the way you will gain confidence and loosen up – the biggest stumbling block to success is lack of assurance and the unwillingness to make advances that can result form this – and start to have fun and really enjoy the challenge of watercolour painting. And who knows? You might even be tempted to venture outdoors and really enjoy yourself sketching and painting from life!

C. M. Evans

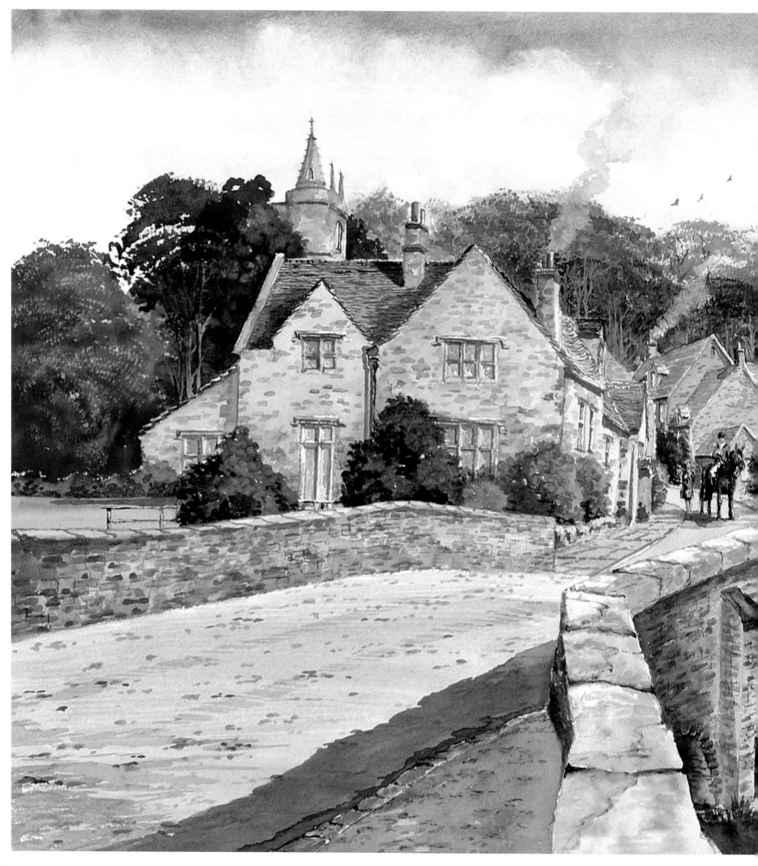

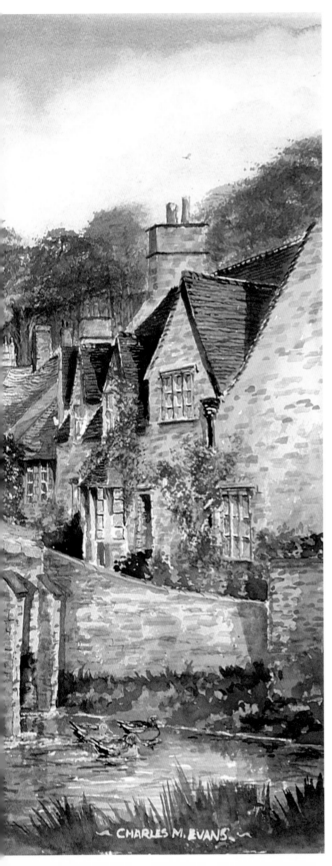

CHARLES M. EVANS

THE PARTS OF A COMPLEX PAINTING

The many different elements in this village street – the river, the narrowing street, the masses of trees and foliage, the figures and the jumble of buildings – probably make this subject look pretty daunting at first sight.

But now have a look at the areas I've picked out on the right and below, which all relate to the exercises and projects in this book, and you'll see that even a complex landscape can be broken down into its parts and then fitted together.

I don't use technical terms where simple, straightforward ones will do, so don't be daunted. Getting there takes practice – but isn't it worth the effort?

SKIES AND CLOUDS

FIGURES

TREES AND FOLIAGE

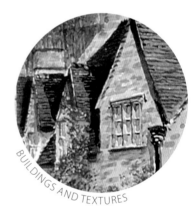

BUILDINGS AND TEXTURES

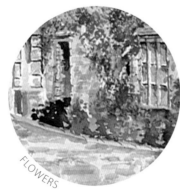

FLOWERS

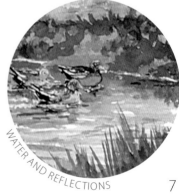

WATER AND REFLECTIONS

MATERIALS AND TECHNIQUES

All the materials used in this book are made by Daler-Rowney, and are easily available at art stores and via mail order. As you'll see in this section, I don't believe in burdening myself with stuff I'm never – or hardly ever – going to use. If you're just starting off, it makes sense to experiment with the basics shown here and buy additional materials only when you can't do without them.

THE WORKSPACE

On my travels around the world I've seen all sorts of workspaces: some people paint in their garden shed, some in an attic room with a skylight, some at the kitchen table and some in conservatories – and some even have the luxury of a purpose-built studio.

Possibly the most unusual 'studio' I've seen was a two-berth caravan with the roof cut off and a sheet of clear acrylic inserted: it certainly wasn't glamorous, but my word, what a fabulous workspace that was!

Wherever you paint, it's important that your workspace should be comfortable and relaxing, but above all it must be well lit. There is a great array of daylight simulation bulbs and lights available; these aim to replicate bright daylight in a north-facing room, and if you haven't tried working with them before, you'll find they really can make a difference to the colours in your paintings.

In my opinion, however, the best workspace of all is outdoors; it may take a sunny summer day to tempt you outside, but there really is no substitute for natural daylight.

In the studio
My indoor workspace is a converted pig barn – now cleaned up and adapted to make the best use of the light from outside. When artificial light is needed, a daylight bulb keeps colours accurate.

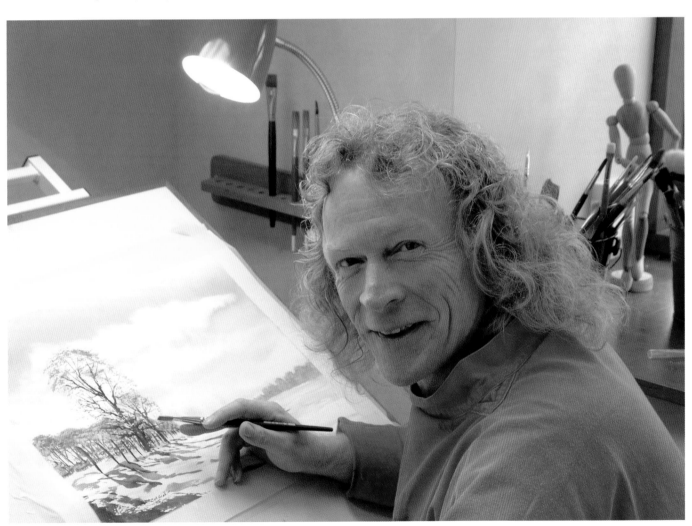

PAINTS

Watercolour paints come in two types, with two grades in each type. You can buy paints in liquid form in tubes or dried in cakes called pans (small cakes are called half pans). I find tubes easier to use, as you can squeeze them out on to the palette and make up washes more quickly and in greater quantities than with pans; it's also simpler to mix colours from tubes and to keep each basic colour clean in the palette.

The grades available are artists' quality, which have a large proportion of pure pigment, and students' quality, which contain less pigment and more fillers. Although students' quality paints are a uniform, lower price, it's better to save up and buy the best paints you can get – for a start, you don't actually need that many, and second, there really is a difference in what you can achieve.

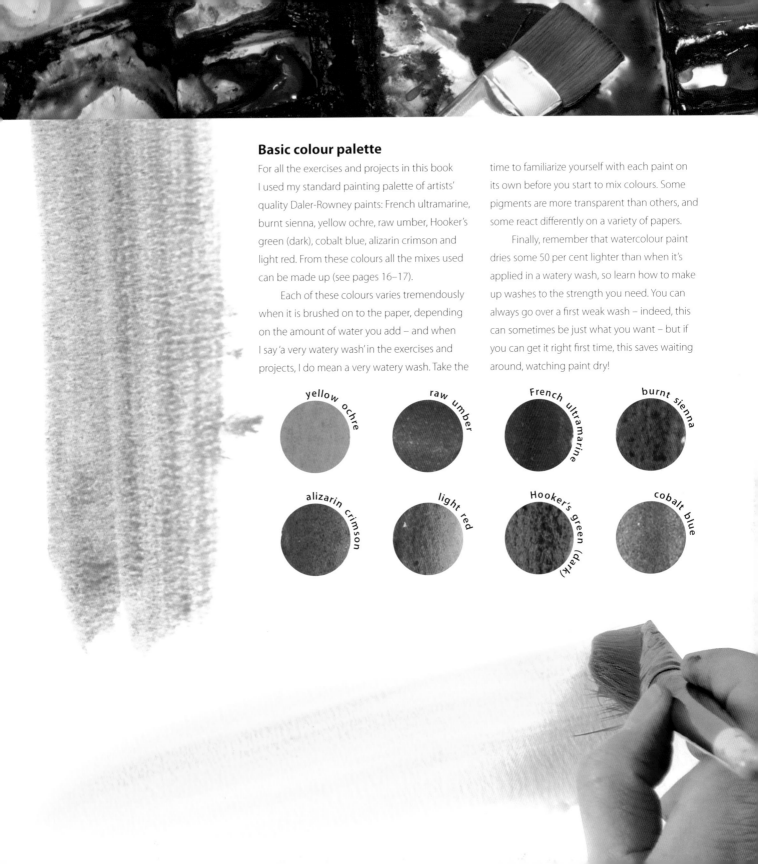

Basic colour palette

For all the exercises and projects in this book I used my standard painting palette of artists' quality Daler-Rowney paints: French ultramarine, burnt sienna, yellow ochre, raw umber, Hooker's green (dark), cobalt blue, alizarin crimson and light red. From these colours all the mixes used can be made up (see pages 16–17).

Each of these colours varies tremendously when it is brushed on to the paper, depending on the amount of water you add – and when I say 'a very watery wash' in the exercises and projects, I do mean a very watery wash. Take the

time to familiarize yourself with each paint on its own before you start to mix colours. Some pigments are more transparent than others, and some react differently on a variety of papers.

Finally, remember that watercolour paint dries some 50 per cent lighter than when it's applied in a watery wash, so learn how to make up washes to the strength you need. You can always go over a first weak wash – indeed, this can sometimes be just what you want – but if you can get it right first time, this saves waiting around, watching paint dry!

yellow ochre

raw umber

French ultramarine

burnt sienna

alizarin crimson

light red

Hooker's green (dark)

cobalt blue

BRUSHES AND PAPER

This may come as a bit of a surprise, but you really don't need great rafts of equipment that clutter up your workspace or weigh you down when you're out sketching.

My attitude is that if I can't keep it in my painting bucket or hold it in my hand, it's surplus to requirements; and the fewer bits of stuff you have to think about – most of which you may never use – the more you can concentrate on what you really want to do: paint. Of course you don't have to use exactly the same brushes and paper that I do, but keep what you do choose to a mimimum, and you'll be on the right lines.

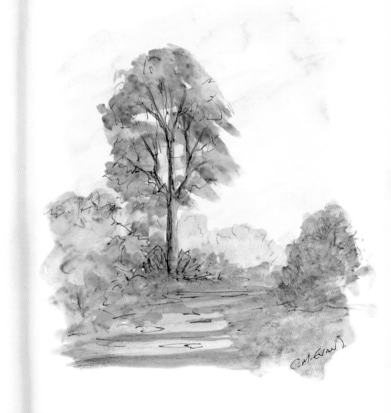

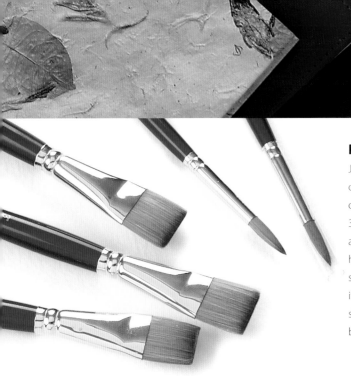

Papers

Just as with all art equipment, there's a huge choice of papers, and you can spend too much time worrying about finding the perfect one. My choice for my own paintings, and for everything in this book, is 300gsm (140lb) Langton Rough, which has a couple of great advantages: it's identical on both sides (some papers have a right and a wrong side), so you can just start working, and you don't have to stretch it before painting – I just cut a large sheet in half and tape it to my board with masking tape.

Brushes

Throughout this book I've used the same four brushes I use for all my painting. The largest is a 38mm (1½in) Dalon flat wash brush, which is totally synthetic, meaning that it can stand up to all sorts of hard work – I've used and abused mine for over 10 years and it won't win any beauty prizes, but it still does a really good job. This is the brush for covering the paper quickly, such as when stroking on clean water or making preliminary large washes for skies.

The other three brushes – a 19mm (¾in) flat wash, a No. 8 round and a No. 3 rigger – are a blend of synthetic and sable from the Sapphire range: the sable gives great flexibility and pointing for the round brushes, and the synthetic bristles are tough and long-lasting. As you will see in the exercises and projects, I use the rigger for putting in final touches, the smaller flat wash for broader strokes, and the No. 8 for much of the work in between these.

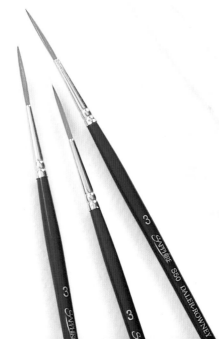

OTHER EQUIPMENT

You'll have gathered by now that the aim of the game is to get painting, so you don't need to clutter up your workspace with bits and bobs that don't make life easier and only get in the way; all you need is a very few extra bits of equipment, and off you go.

Palettes

The most useful rule for a palette is that the wells should be big enough to make up as much wash as you need – if not more – so you don't run out and have to make up new washes. Because I mostly use the same range of colours for all my paintings and mix from these, I can leave the paint to dry out in the palette and just clean out the wells at the end of the day.

Boards and tape

You need something stable and with a smooth surface for a board – a piece of MDF rounded at the edges is fine, but don't get anything too thick and heavy.

Because I don't wet and stretch my paper before painting (see page 13) – which can just lead to another level of anxiety – I use ordinary masking tape to secure the paper to the board.

Pencils

This is easy: I use any old pencil I can lay my hands on, as I use a pencil only for simple outlines – no crosshatching, shading or toning. Pencil sharpeners tend to eat pencils, so it's best to use a sharp penknife for sharpening.

Watercolour pencils

These are great for quick colour sketches on location (see page 18), and you can use them dry or wet, as adding water makes the pigment behave like watercolour paint. A box of watercolour pencils isn't expensive, and it's nice to have a big range of colours, although I find that I use most of them only occasionally and stick to certain colours, just as with paints. Another advantage is that if you're sketching outlines with watercolour pencils and you make a mistake with an outline – which every artist does – you don't need to erase the error: just stroke some water over the line and, hey presto! The mistake vanishes.

As with pencils, use a penknife to sharpen watercolour pencils; this way, the points don't become brittle, and last longer.

COLOUR

A large number of people confuse both themselves and their palettes by using too many colours: if there are 85 colours on offer in a colour range, as a beginner you may feel you need 84 of them immediately – but this means you have no chance of learning to mix fresh, vibrant colours, as you're almost certain to end up with flat, muddy mixes.

The best thing is to limit your palette to a few workable and mixable colours – my selection, shown on page 11, is a good start and has served me well for many years – and to play around with them; after all, isn't painting supposed to be fun? It's amazing what you can come up from a bit of experimenting with a few colours.

Another reason to keep the number of colours down is for when you go outdoors with a sketchbook and maybe an easel (see pages 18–19); the last thing you need is to carry a lot of gear, and popping eight small tubes in a pocket will see you through most scenes and situations.

Mix, match and enjoy!

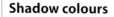

Shadow colours

Rule 1 for shadows is that they are never just black. There is always a blend of the colour cast by the object and the colour of the surface on to which it is cast – even if the latter is white. In the Sunday paintings I use a lot of shadows, particularly in the sky, where clouds cast shadows on to each other, and the examples here show three of these; the two blues mixed with burnt sienna and alizarin crimson produce quite different shadows. In the bottom row, note that I make up a black and then dilute it with more blue in the mix to give a second mix of the colours.

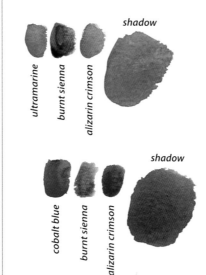

shadow

ultramarine • burnt sienna • alizarin crimson

cobalt blue • burnt sienna • alizarin crimson

shadow

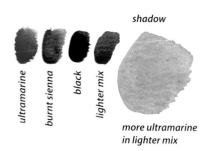

shadow

ultramarine • burnt sienna • black • lighter mix

more ultramarine in lighter mix

Mixing greens

In my standard palette I use only one pre-made green, Hooker's green (dark). When used straight from the tube this is a pretty awful colour, but if I mix it with the other seven colours in the palette one at a time, this gives me seven different greens, some of which are shown here.

If that isn't enough I can then add a third colour to some of these mixes, giving me up to 12 greens. The danger with doing this is that you can end up mixing mud – inevitable in the landscape,
but not in paintings – but if you vary the water in each element of the wash you should be able to avoid this and end up with a set of lovely clear greens. And you'll need these: look at any tree in leaf and you'll see not one, but a huge number of subtle greens.

Hooker's green *burnt sienna*

strong green

Hooker's green *burnt sienna* *ultramarine*

darker green

Hooker's green *yellow ochre (weak)*

yellowy green

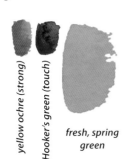

yellow ochre (strong) *Hooker's green (touch)*

fresh, spring green

Hooker's green *light red*

autumnal green

Sienna, ochre and umber

A lot of people like to use raw sienna for their basic yellow shade, as opposed to yellow ochre, but I stick with ochre. True, it's a more opaque paint than raw sienna, but the answer is to stick loads more water into yellow ochre until it becomes transparent. This way you can avoid the potential problems of using raw sienna, which can become muddy very easily when mixed with certain other colours.

If you want to make the colour of raw sienna without having the paint ready-made, mix a tiny bit of raw umber into yellow ochre, and there you have a great mix, which is useful for the colour of stonework on a building, for instance.

The examples here show the versatility of the 'brown' range of colours in my limited palette, and all are used in the projects in this book, for everything from tree trunks to human arms and legs.

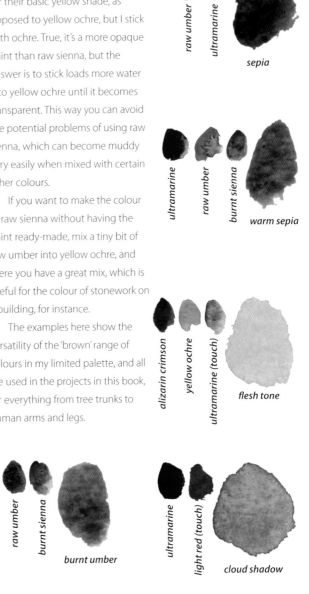

raw umber *ultramarine*

sepia

ultramarine *raw umber* *burnt sienna*

warm sepia

alizarin crimson *yellow ochre* *ultramarine (touch)*

flesh tone

raw umber *burnt sienna*

burnt umber

ultramarine *light red (touch)*

cloud shadow

SKETCHING AND WORKING OUTDOORS

Most of the themes in this book are based on landscapes, and there is no substitute for getting out there. Painting outdoors means that you put down on paper only what you want to include, and cut out anything unnecessary – and taking a sketchbook and light materials is a great way to make a holiday even more enjoyable.

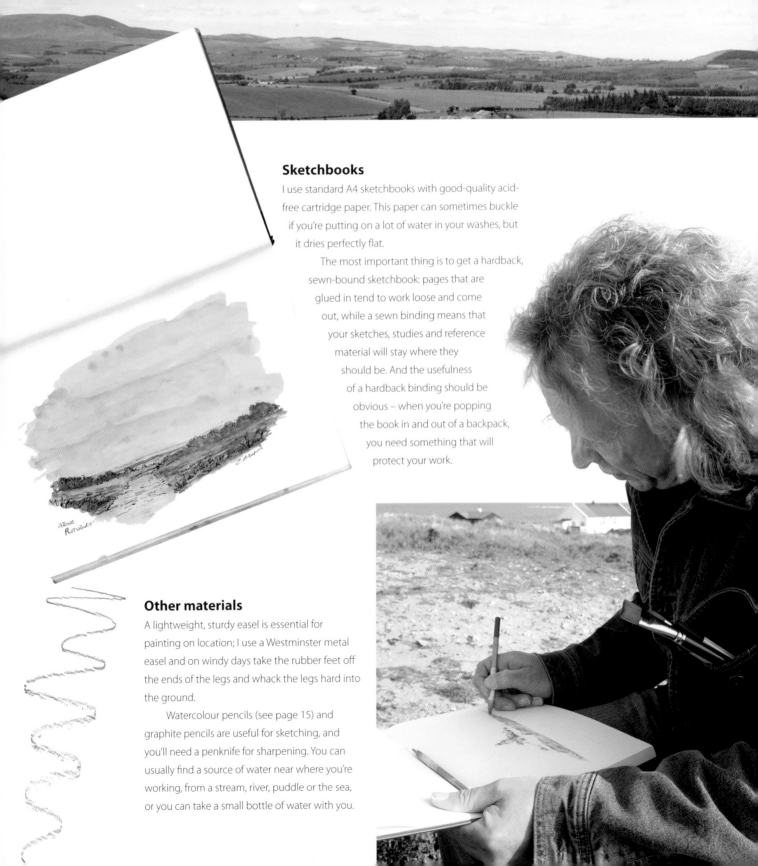

Sketchbooks

I use standard A4 sketchbooks with good-quality acid-free cartridge paper. This paper can sometimes buckle if you're putting on a lot of water in your washes, but it dries perfectly flat.

The most important thing is to get a hardback, sewn-bound sketchbook: pages that are glued in tend to work loose and come out, while a sewn binding means that your sketches, studies and reference material will stay where they should be. And the usefulness of a hardback binding should be obvious – when you're popping the book in and out of a backpack, you need something that will protect your work.

ABOVE ROTHBURY

Other materials

A lightweight, sturdy easel is essential for painting on location; I use a Westminster metal easel and on windy days take the rubber feet off the ends of the legs and whack the legs hard into the ground.

Watercolour pencils (see page 15) and graphite pencils are useful for sketching, and you'll need a penknife for sharpening. You can usually find a source of water near where you're working, from a stream, river, puddle or the sea, or you can take a small bottle of water with you.

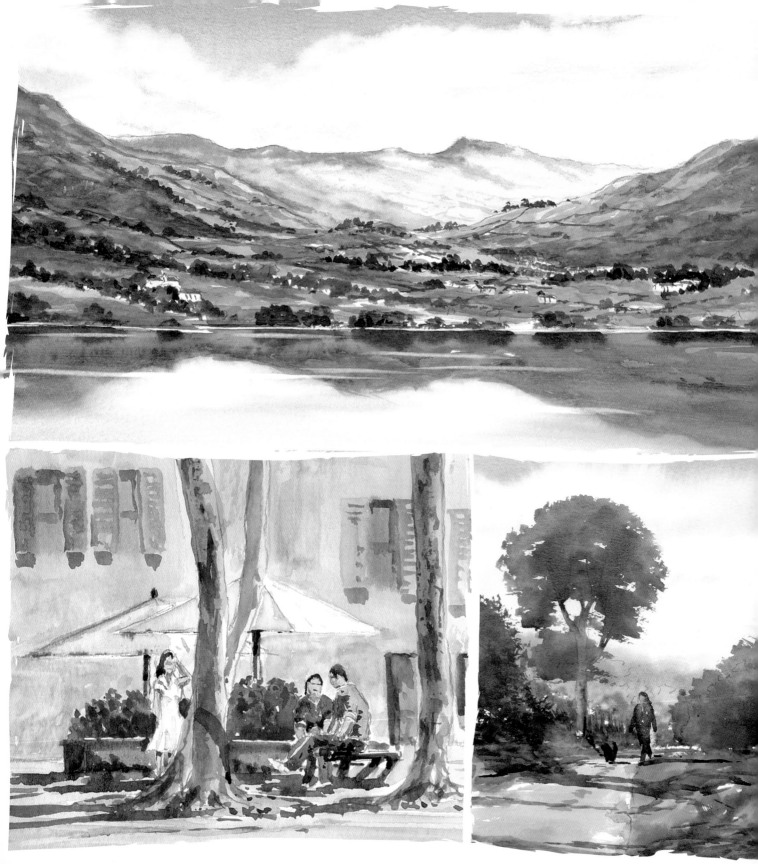

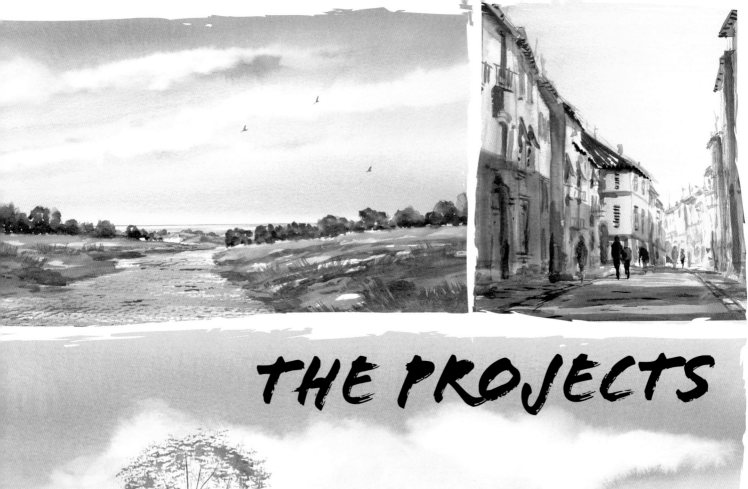

THE PROJECTS

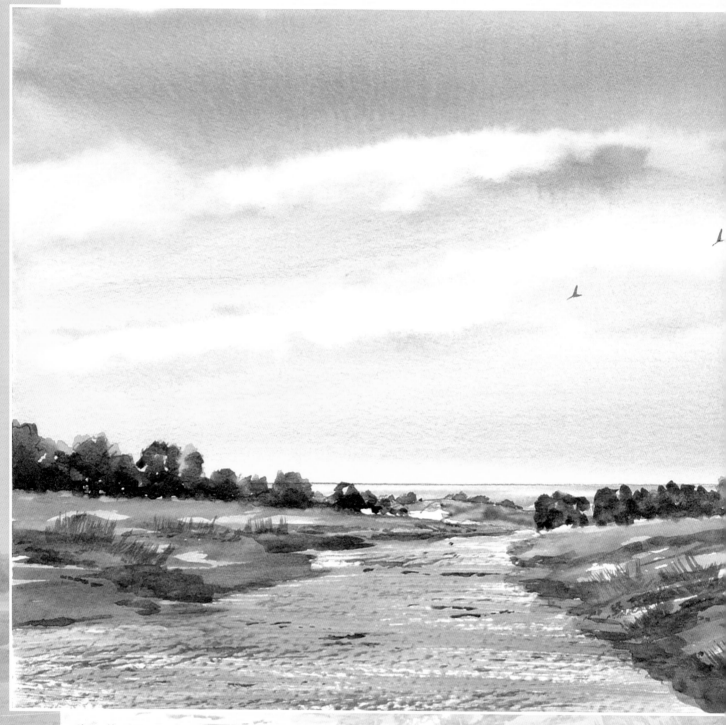

Sky and land
In this finished painting I've drawn the outlines much more distinctly than I normally would, for the purposes of making them visible in the steps for the Sunday painting.

SKY AND LAND

All watercolour painting is about laying transparent washes on to the paper and building up from lighter colours to darker ones. This first project shows you how to put down the simplest washes and use them to make a finished painting.

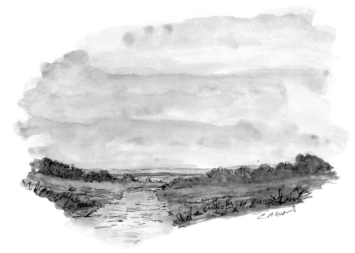

Reference sketch
I used watercolour pencils to draw this quick little vignette, setting down the basic shapes and colours of the scene in front of me. It took 10 minutes.

Flat and graded washes

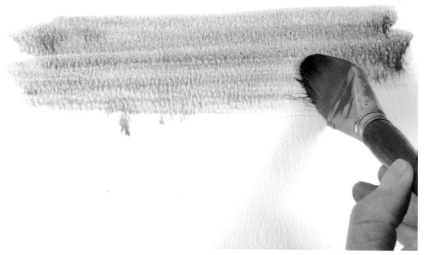

1 A flat wash is useful for large areas such as the sky or a background for the land, and is the basis of all watercolour painting. Make up a large amount of a watery wash of ultramarine. First use a 38mm (1½in) flat wash brush to wet the whole of the paper with clean water. Then load the brush with paint and stroke the colour on from side to side, working down the paper.

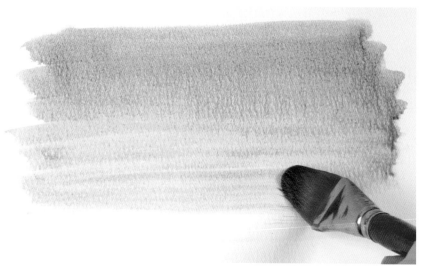

2 Continue to work down the wet paper, working quickly and reloading the brush as necessary to make sure the colour stays as much the same as possible from top to bottom.

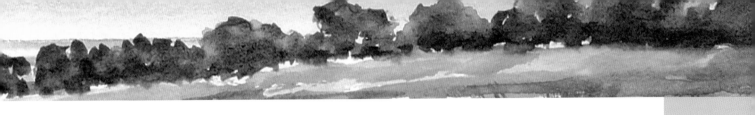

3 If you find that the coverage is uneven, you can add more paint where you've already been – but don't take any time over this: just whack on the paint while everything is still wet. It takes practice to achieve a flat wash, and different colours go on the paper in different ways, so be ready to use a lot of paint and paper.

4 At the bottom of the wash you may find that you have a line or bead of watery paint – don't leave this as there's a chance it may seep up the wash as it dries, leading to the dreaded back-run or 'cauliflower' effect. Squeeze the bristles almost dry and go along the bead of paint with the brush edge, sucking water out of the paper.

5 Graded washes are great for skies and for tinting paper before painting. Wet the paper with clean water as before, which avoids hard edges as the paint dries, then start as in step 1 opposite, working quickly from side to side.

6 As you go down the paper this time, don't refill or load the brush again, but continue to whack it on with gusto – as the paint runs out the wash gets weaker towards the bottom, and the result is a graded wash.

SKY AND LAND 25

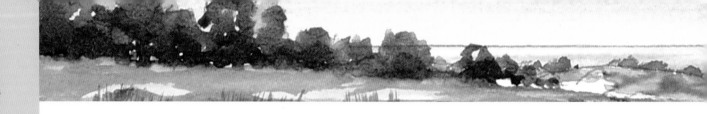

Variegated washes

1 A variegated wash, in which you blend two colours, is a simple way to start a little landscape. Wet the paper as for the previous exercises and paint a flat wash of yellow ochre along the bottom third of the wet area.

2 While this is still wet, rinse the brush and start a graded wash of cobalt blue from the top, using plenty of water and not recharging the brush as you go down the paper.

3 Bring the strokes of faint blue down over the top of the still-wet yellow wash, stopping a few strokes down. Don't go back over either wash, and allow everything to dry naturally and completely. And there's a variegated wash ready to develop.

4 The horizon line is where the yellow land blends into the blue sky. Make a mix of Hooker's green and burnt sienna, and use a No. 8 round brush to drop some blobs for tree tops just above the horizon.

5 Work across the paper, adding a horizon line – which doesn't have to be dead straight – and some more blobs for trees. Leave a little background visible in the trees to give the birds gaps to fly through.

6 Distant tree trunks are easy: just use the tip of the brush to add a few lines from the leaf canopy to the ground. Note that you don't have to paint the horizon across the whole paper – you're only concerned with the trees, and the 'lost line' adds interest.

7 Make up a very watery, diluted wash of the tree colour, and stroke the tip of a flat wash brush to make gentle contours across the land. Don't try to cover the whole of the yellow area, just show the shadows. You've just painted a landscape!

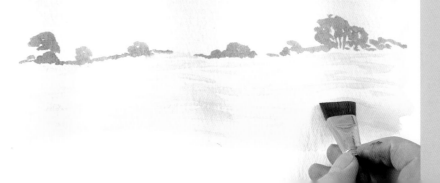

27

SUNDAY PAINTING

yellow ochre

burnt sienna

ultramarine

Hooker's green

This first project, a moor leading down to the sea in the far distance, uses variegated washes for the sky, which takes up most of the painting. Make sure that the horizon line isn't exactly halfway up this kind of composition, as it will split the painting in half and lose the interest of the sky; note how the path leads the eye just to the left of the centre of this painting for the same reason.

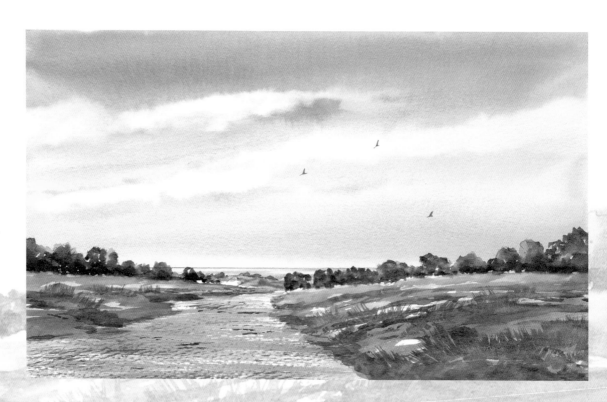

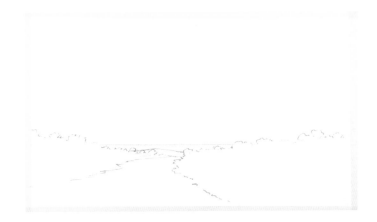

Preliminary drawing

The pencil outlines show the basic and very simple shapes of the sea, trees and path – the sky will form itself as you paint it. Note how the path, appearing narrower as it leads away into the distance, helps to create the effect of recession, which I'll look at in a bit more depth in the next project.

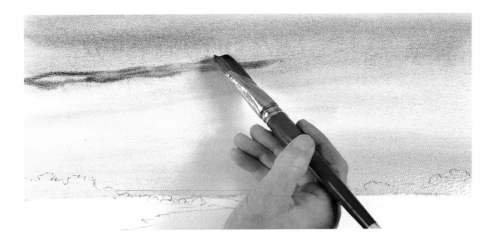

Step 1

Thoroughly wet the sky area with clean water, then use a 38mm (1½in) flat wash brush to stroke a wash of yellow ochre mixed with a touch of burnt sienna across the bottom third of the sky, down to the line of the sea and treetops. Leave a little white paper on the right.

Step 2

While this is wet, add a watery wash of ultramarine from the top and blend it into the yellow for a variegated wash. Put a few strokes into the white paper you left in the first wash. Use the side of the brush to put in a few darker areas of ultramarine mixed with burnt sienna.

Step 3

Now it's time to add a few soft-edged clouds. While the sky is still wet rinse and squeeze out the brush and use it to suck the paint out of the wash, moving the brush around on the paper. This is such an effective technique that's it tempting to use it more than you need – do your best to resist the temptation.

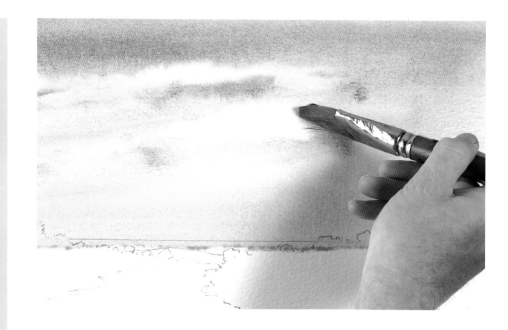

Step 4

Let the sky washes dry, but not completely, and start the sea by blocking in the area with a mix of ultramarine and a little Hooker's green, applied with a 19mm (¾in) wash brush. Rinse and squeeze out the brush, and use the tip to suck out a line of paint to create a strip of light out at sea.

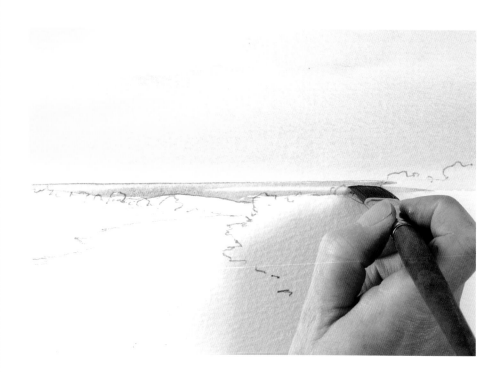

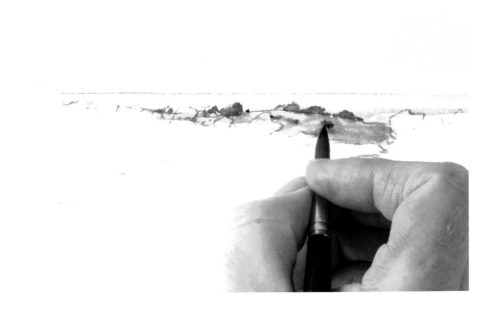

Step 5

For the very furthest stretch of land down by the sea, switch to a No. 8 round brush and block in the area with yellow ochre. While this is wet drop in a mix of Hooker's green and burnt sienna – keep the colours very weak to give a sense of distance. Allow to dry a little, then dab in a few blobs of Hooker's green mixed with yellow ochre for some trees on the way to the sea.

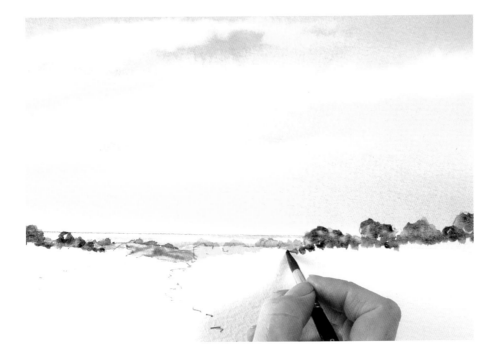

Step 6

Following the pencil lines on the left and right headlands, dab on a watery wash of yellow ochre for the trees, then tap on a darker mix of Hooker's green and burnt sienna here and there, letting some of the first wash show through. While this is wet, put a tiny touch of ultramarine at the base of the trees for some shadows that help anchor the trees to the ground.

Step 7

Go back to the smaller wash brush to paint a light wash of yellow ochre over the path and fields, leaving lots of white paper in the latter to catch the light (rough paper is best for this). Stroke a mix of Hooker's green and burnt sienna over the fields, using curved strokes to follow the contours of the ground; again leave the white and first washes showing. Make the washes stronger as they come into the foreground to give a sense of recession into the distance.

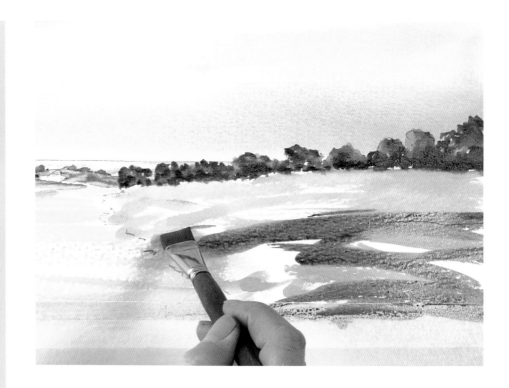

Step 8

If a path is left to the end of a painting it sometimes looks too clean – dirty this one with a fine watery wash of mixed ultramarine and burnt sienna. Drag in a hint of green from the sides of the path, and let everything dry for a few seconds. Now all the landscape is in there.

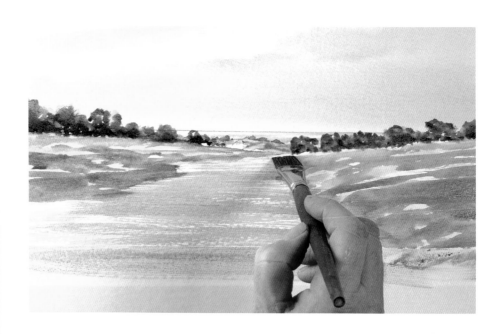

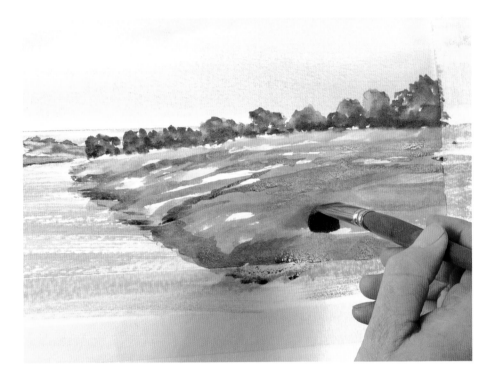

Step 9

Make a rich mix of Hooker's green, burnt sienna and ultramarine, and use the smaller wash brush to tap a few darker areas into the grasses, and to edge the path a bit. You don't need to paint individual blades of grass – push the wash brush on to the paper and flick it up to create tufts of grass. Note that the highlights are still white paper – the finest white you can use.

Step 10

Now you're on to the finishing straight: put in a few lumps and bumps on the path with a mix of ultramarine and burnt sienna. Then add a bit of life – use a No. 3 rigger brush to flick a few ticks of the same wash into the sky for a trio of seagulls. That's the landscape, and it wasn't difficult, was it?

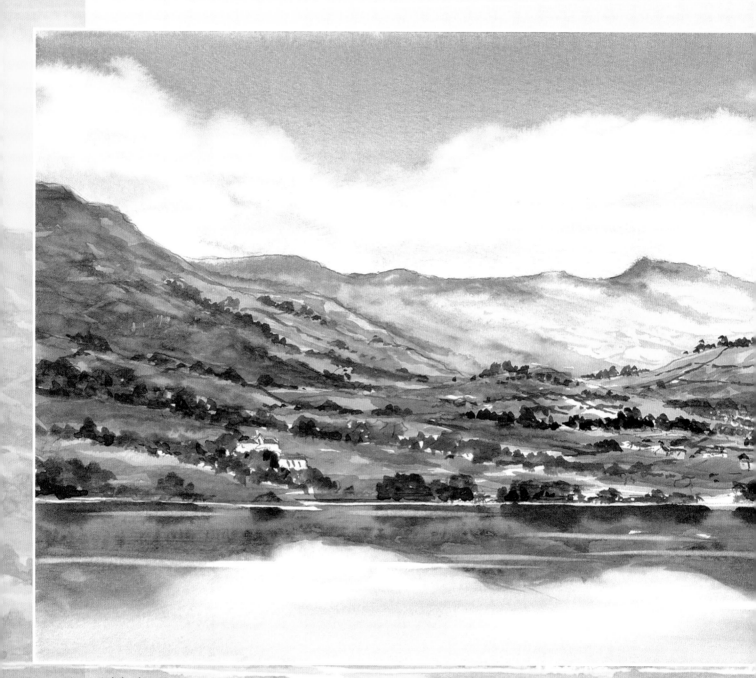

Lakeland scene
Include just a few houses to set the scale, but you don't need to go into any detail – the mountains and lake are the points of greatest interest in this landscape.

MOUNTAINS AND LAKES

In the previous project the water was far off in the distance; here it is in the foreground, reflecting the mountains that stretch away up to the sky. Reflections and recession are explained in the Saturday exercises, and the Sunday painting brings together all the techniques looked at so far.

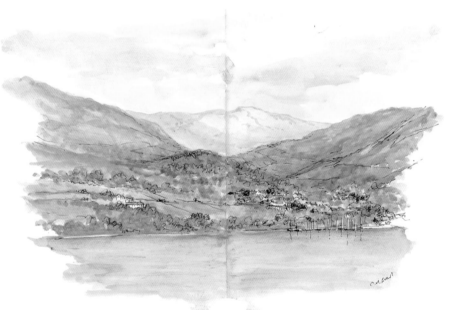

Reference sketch
Working from life I included all the houses in the village on the right and a number of boats, but dropped them from the final painting.

Recession

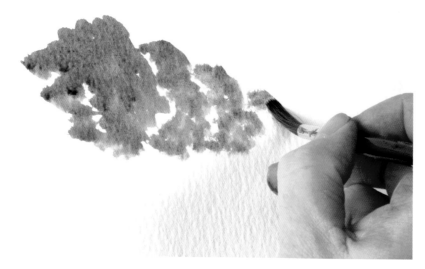

1 Recession is linked with perspective (see project 5) in that similar objects appear smaller as they become more distant – if they are vertical make them shorter, and if they are horizontal make them narrower. With tonal recession, the colours get fainter the further away they are. Use a green mix and No. 8 round brush to paint clumps of trees, starting large in the foreground with a fully loaded brush.

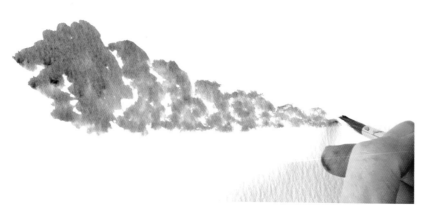

2 As you move away from the first tree, replicate the shape but make the next one shorter at the top – and don't refill the brush, but let the colour get weaker as you go along. Dip the brush into clean water as you approach the end of the line of trees. Don't forget to leave some white between the clumps for shadows and a few gaps in the leaves.

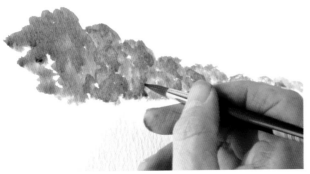

3 Let the green dry a little, then add ultramarine for the shadows, again starting with a strongish wash in the foreground and dipping the brush into clean water as you get further away.

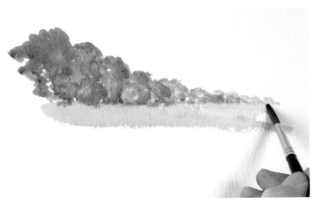

4 To aid the feeling of recession, don't leave the trees floating in mid-air – attach them to the ground. Add a field of raw sienna, this time painting a graded wash upside down ...

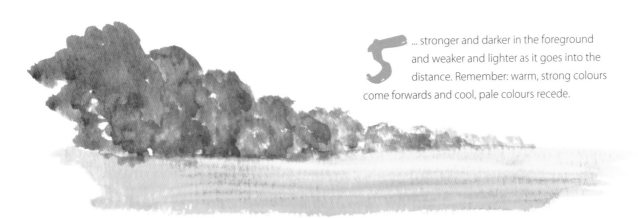

5 ... stronger and darker in the foreground and weaker and lighter as it goes into the distance. Remember: warm, strong colours come forwards and cool, pale colours recede.

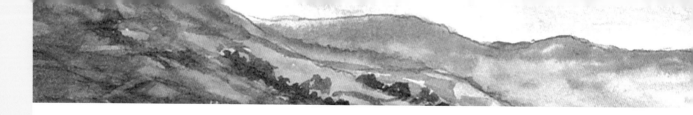

Reflections in still water

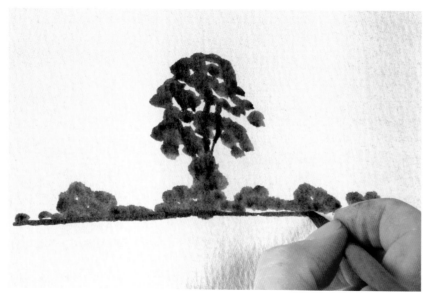

1 Paint a flat wash (see project 1) for the background and let it dry completely. Use a No. 8 round brush to make a few daubs and blobs of a mix of Hooker's green and burnt sienna for a tree (see project 4). Add some bushy blobs at each side and make a fairly straight line at the base for the edge of the water.

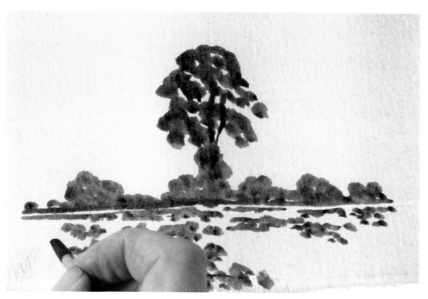

2 The secret of painting still reflections is to invert what's above the water, while leaving parts of the underwash showing through here and there and breaking up the solidity of the reflected objects. If your viewpoint is close to the surface of the water the reflections are going to be a little longer than the actual trees, so the reflections will come out further towards the foreground, while remaining as wide as the originals. Don't try to make an exact copy in the water.

Reflections in moving water

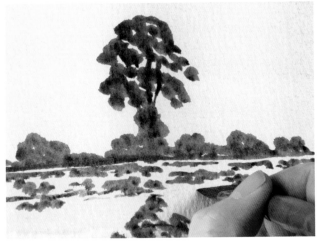

1. Use the same technique to paint the trees and bushes; this time break up the reflections a bit more and allow to dry.

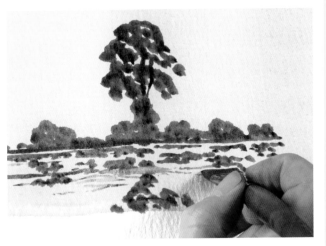

2. Use a flat wash brush to stroke some ripples in a strong ultramarine wash to show the movement of the water.

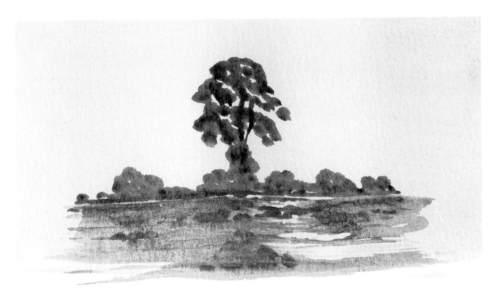

3. Stroke a diluted blue wash over the reflections, making the movement of waves and ripples and leaving the underwash to show as highlights here and there. Add a few stronger ripples, and there you have moving water.

SUNDAY PAINTING

yellow ochre

alizarin crimson

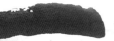

ultramarine

burnt sienna

Hooker's green

light red

This view of Coniston Water in the English Lake District is slightly more difficult than the last project – but not scarily so. It's a view from John Ruskin's house (see project 6), and looking at this you can understand why he never wanted to leave the place. The painting combines the basic themes of sky and land with the Saturday exercises in this project to create a complex finished picture.

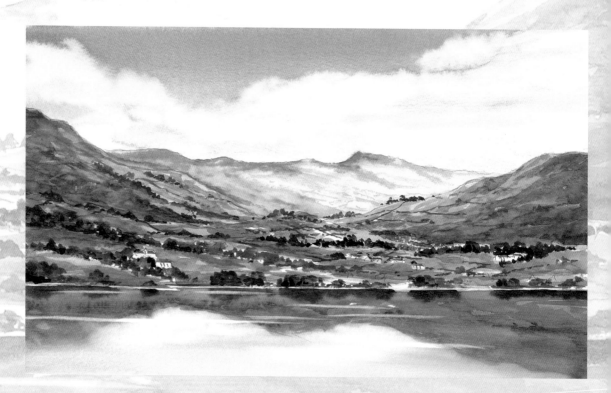

Preliminary drawing

The drawing here takes up only the middle third of the paper, from the tops of the mountains to the edge of the lake – the reflections will be based on the results of painting the scene on land. I've indicated just a few houses and the darkest clumps of trees here and there.

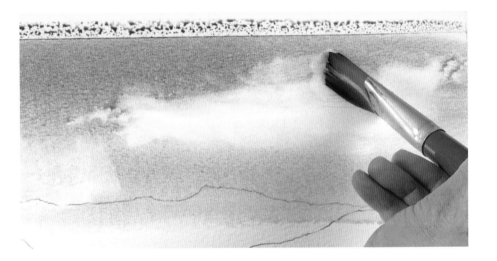

Step 1

Wet the sky area with clean water, then use a 38mm (1½in) flat brush to stroke a wash of yellow ochre with a little alizarin crimson into the bottom third. Then work down from the top with ultramarine to make a variegated wash. Squeeze out the brush and suck out the paint to make soft clouds before adding a few cloud shadows in the white areas with a watery mix of ultramarine and burnt sienna.

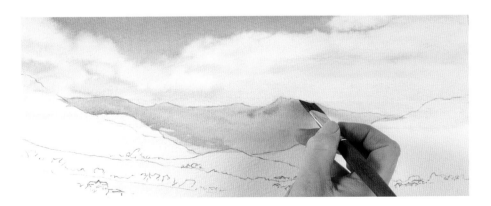

Step 2

With a 19mm (¾in) wash brush block in the most distant mountains with diluted yellow ochre. While still wet lay a watery mix of ultramarine and burnt sienna on top, allowing the yellow to show through in places. Leave this for a while to dry.

Step 3

Stroke a slightly stronger wash of yellow ochre into the mountains on the left and right, leaving some white areas, and allow this to dry. Go back to the now dry distant central mountains and follow the contours with a darker shadow mix of ultramarine and burnt sienna, using a No. 8 round brush.

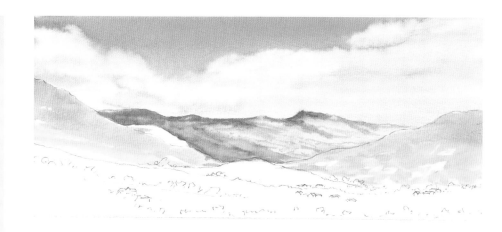

Step 4

Block in the small area on the left between the two ranges with the same colour. Now mix Hooker's green and yellow ochre with lots of water and stroke this on with the larger wash brush – once again, don't go over all the first wash, and let some of the white paper still show through. While this is wet, warm it up in the same way with a watery wash of burnt sienna. Allow everything to dry just a little.

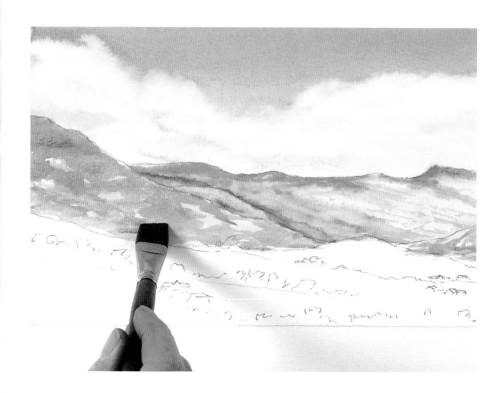

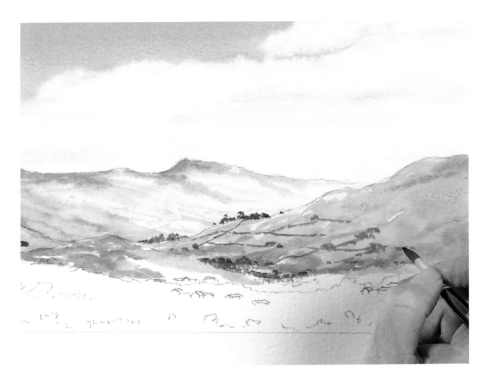

Step 5

Start the hills and fields in the middle distance with the yellow ochre and Hooker's green and burnt sienna washes used before. Add a touch of ultramarine to the mix and use the No. 8 brush to put in some woodlands and boundaries for the field shapes – these follow the contours of the ground and have no verticals or horizontals. Bring the green and sienna mix into the nearest hills, again leaving some white areas.

Step 6

Come into the foreground with the yellow and green and sienna washes, using the larger wash brush; go around the buildings to give yourself the option of leaving them white. While the washes are wet use the No. 8 brush and a mix of Hooker's green and light red for the nearest woodlands, bringing them down to the shoreline. Use a darker mix of Hooker's green and burnt sienna for the trees around and behind the buildings – dab and stipple these lumps and bumps on, with a few squiggly lines for more field boundaries.

Step 7

While these washes are drying, put in literally just a few tiny strokes of light red for the roofs, leaving the white underneath – and there are the buildings with a minimum of fuss. A touch of ultramarine around some of the buildings, but not all, darkens the greens and makes each building stand out more. Allow to dry completely.

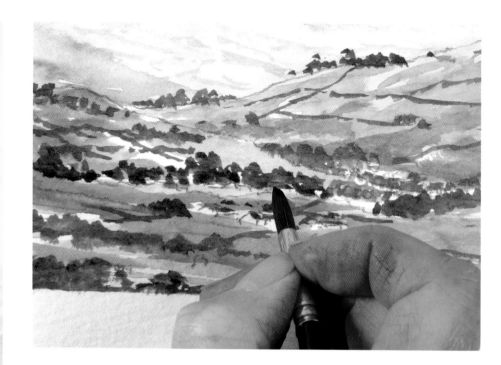

Step 8

Now for the scary bit. Make up a mix of ultramarine and alizarin crimson with no more than a touch of burnt sienna, using lots of water, for a purple shadow colour. Use the smaller wash brush to put the shadows across the hills and into the valleys. You have to be quick and brave here – if you prevaricate or mess around you'll disturb the washes underneath, so use big, simple diagonal strokes for this.

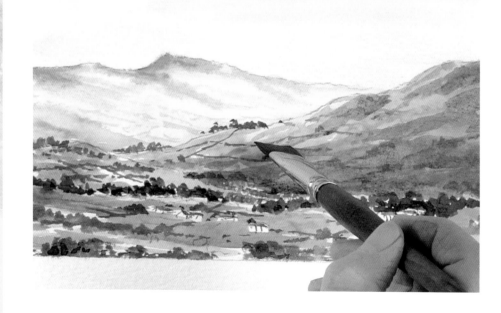

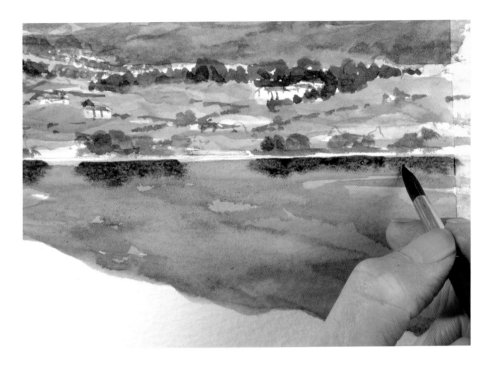

Step 9

Start the water with the reflections of the land, using the Hooker's green and burnt sienna mix again. Don't aim for a perfect reproduction, rather match the big shapes from above, leaving a narrow white strip between the land and the water. While this is wet tap on a little yellow ochre, then with the No. 8 brush add ultramarine to the green mix for the groups of trees near the shoreline. Make sure this is totally dry before going on to ...

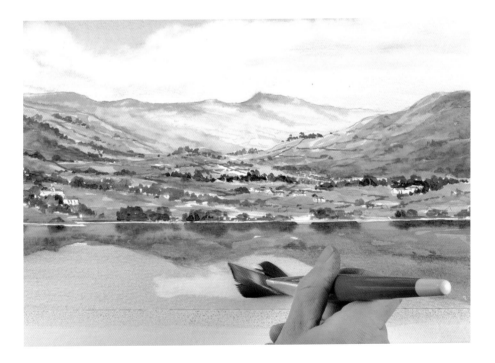

Step 10

... the reflection of the sky. Use the larger wash brush to stroke on a very quick wash of watery ultramarine, then rinse and squeeze out the smaller wash brush to suck out lines reflecting the clouds: for smaller shafts of light use the tip of the brush. And *voilà* – a still lake with a vista of mountains reflected in it.

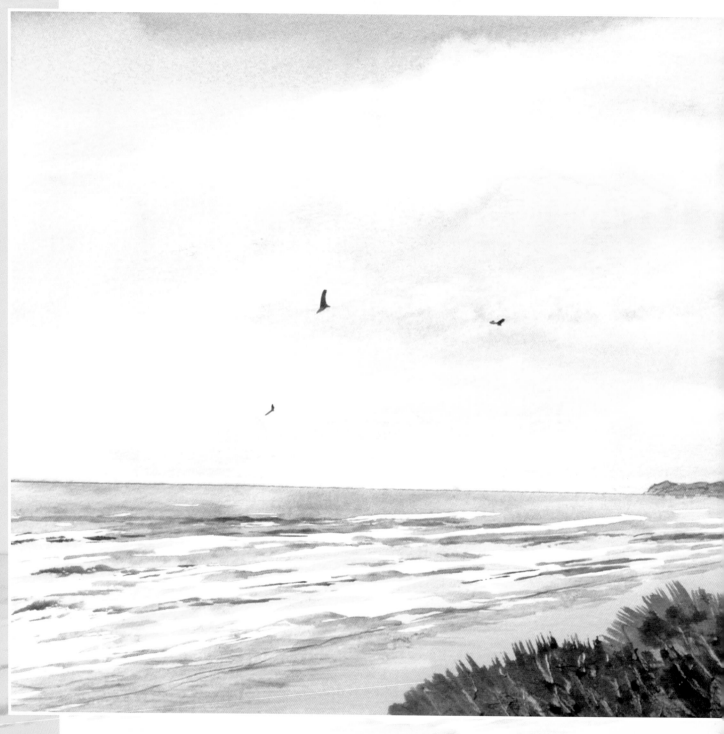

The sea
The coast of Northumberland, where I live, has
many secluded, beautiful views of this sort.

THE SEA

Just as with lakes, painting the sea doesn't mean simply putting a series of washes on the paper to represent a stretch of water. In a seascape it's all the other features that make the scene come to life – sea, shore, dunes, harbours, boats and seabirds all combine to create the atmosphere. And, of course, taking a sketchbook and some pencils and paints makes a visit to the seaside even more interesting.

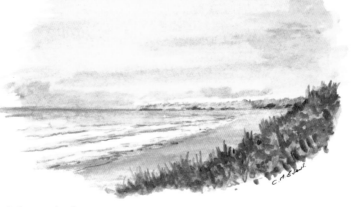

Reference sketch
Comparing this quick colour study from my sketchbook with the finished Sunday painting shows how I edited the scene a little, to add visual impact.

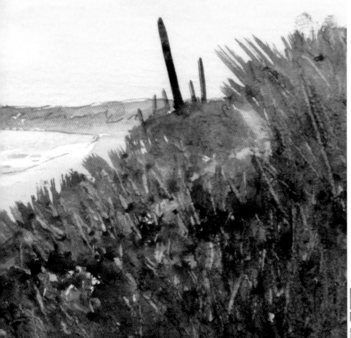

Highlights and wave tops

1 Let's start painting the sea with a fairly simple little exercise that gets some life into the surface as the sea comes in to the shore. Make up a mix of ultramarine with tiny touches of Hooker's green and burnt sienna to warm it up. Use the tip of a 19mm (¾in) brush to stroke a line across dry paper.

2 Go back and forth across the paper, making sure you leave squiggly bits of white paper showing through for the highlights and 'white horses'. Press a little harder to get slightly wider lines.

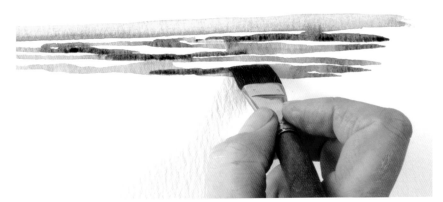

3 To get some sense of distance, paint the furthest areas of the sea using a diluted wash of the same colours. Let this first wash dry out, then make up a darker version of the mix and stroke this just under the white highlights to give a sense of motion.

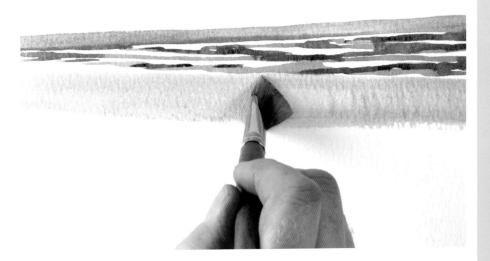

4 Now you need to put the sea into context. When the washes are completely dry, make up a watery wash of a beach colour – I used sand from the Charles Evans range – and paint in a strip of beach that meets the edge of the sea. And there you are.

Movement in the sea

1 To add some movement to a fairly simple large expanse of sea, start with the same sea wash used on the previous pages. Using a No. 8 brush, apply this quickly, again without wetting the paper beforehand. Start in the distance and bring the wash forwards, using the point of the brush to form the tops of the waves.

2 As you come closer to the shore, make the mix a little stronger. Then add a touch more Hooker's green and plenty of water and start to stroke in some shadow in the foam under the wave tops, still leaving plenty of white paper.

3 As you bring the shadows in the foam towards the shore, vary the strength of the washes to bring in both darker and lighter areas. Keep all the washes very watery and make sure you don't overwork the paint – less is more here.

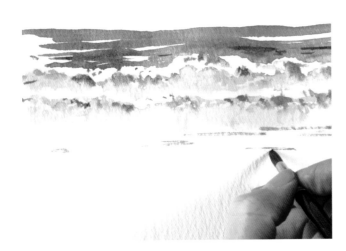

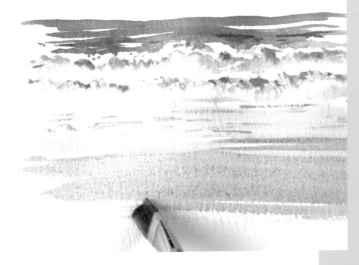

4 Still keeping everything simple and using the same mix, add a few horizontal lines of a fairly strong wash for the water on the shore. As with the shadows in the foam, use a very watery wash to fill in this area, but again leave some patches of white paper.

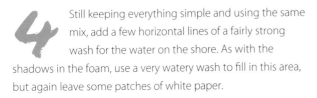

5 While this is still wet, switch to a 19mm (¾in) wash brush and use both the flat and the side to stroke on a light wash of sand colour for the beach (you can also use a touch of yellow ochre for this). Blend this lightly with the blue, aiming for freshness, and stop sooner rather than later.

SUNDAY PAINTING

Hooker's green

Mediterranean sea

ultramarine

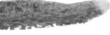

sand

burnt sienna

cobalt blue

light red

raw sienna

This project combines the techniques we have just looked at for painting seas with those for sky and land, as well as some recession, of course. Starting with some quick washes for the sky, you'll drop in a lively sea, full of movement, and progress to the rich, varied colours and textures of the grasses on the foreground dunes.

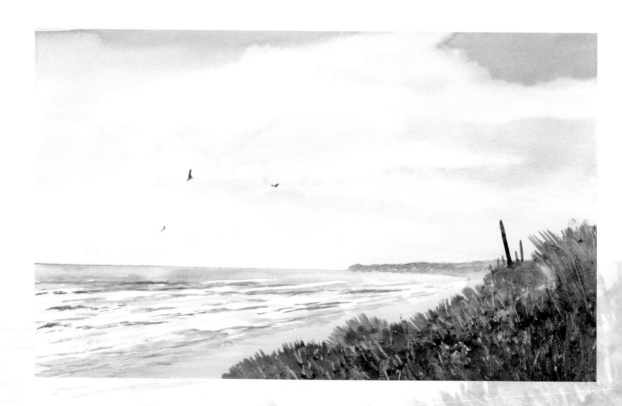

Preliminary drawing

In this simple outline for the painting, the foreground focus is on the sand dunes and the sea, with a small amount of beach. The horizon line is well below the middle of the paper, and the distant headland stops before it gets to the middle of the composition – this both leads the eye and avoids too much regularity.

Step 1

Start by wetting the whole of the paper with a 19mm (¾in) wash brush. While it is wet, use the same brush to colour the whole sky area with raw sienna, going down into the sea and horizon as part of the pre-tinting. Allow this to dry thoroughly.

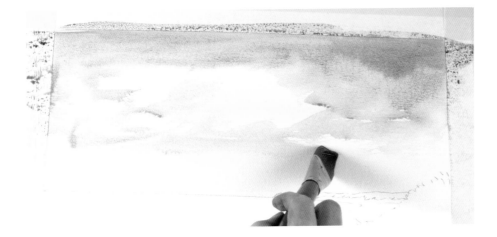

Step 2

Make up a wash of cobalt blue with lots of water and go over the sky area, this time leaving touches of the underwash showing through. Squeeze out the brush and soften the edges where the blue meets the sienna.

Step 3

When the sky has dried, start blocking in the furthest part of the sea using Mediterranean sea and the wash brush. Just block in up to the pencil horizon line, then as you get closer to the shore, use the tip of the brush and leave quite a few squiggly bits of white paper showing through to represent the tops of the waves.

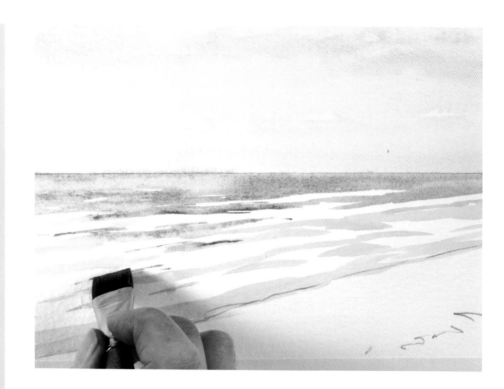

Step 4

While the sea is still wet, drop in a few slightly darker lines of the Mediterranean sea wash under the white lines, to give even more movement. Then stand back and take a look while it dries – simple but effective.

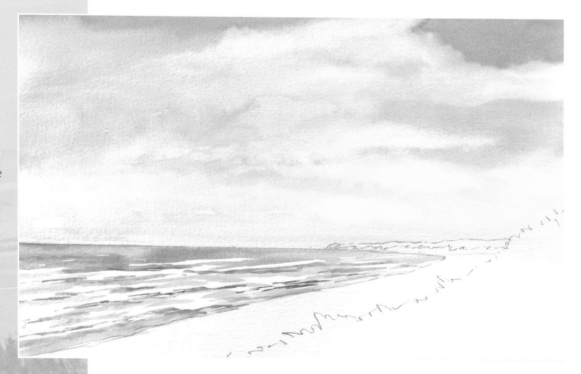

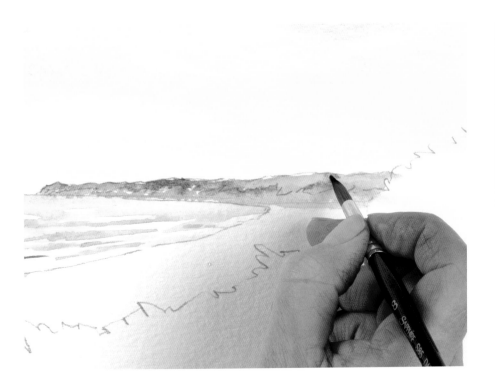

Step 5

Switch to a No. 8 round brush for the distant headland, and colour in the tops with a light mix of Hooker's green and yellow ochre. While this is wet, fill in the dunes below with a mix of yellow ochre and sand, allowing the edges to seep into each other with a soft edge. You don't need any detail, but dab on a mix of cobalt blue and light red to give a little texture, undulation and shadow.

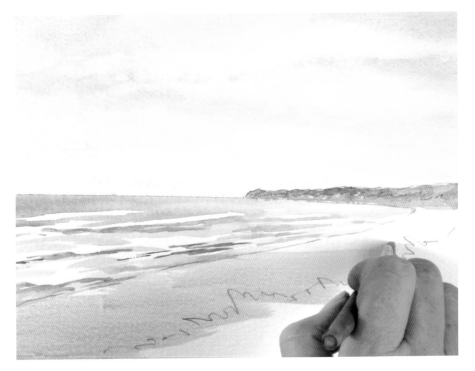

Step 6

Use the wash brush to block in the beach with the same yellow ochre and sand mixture as before, only this time a little darker as it's closer to you. Don't worry about going over the pencil lines as I did here – just aim to get a nice even colour on the beach area.

Step 7

While the beach dries, clean out the wash brush, and then start the foreground with a few flicks and dabs of strongish yellow ochre – whack the paint on and don't be scared of it. There'll be lots of colours on this section in a moment, so you can work boldly.

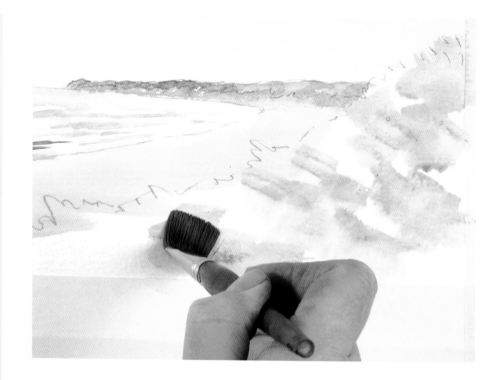

Step 8

While the yellow ochre is wet, flick some light red into it, working upwards to give a grassy effect. While this is still wet, do the same with a mix of Hooker's green and burnt sienna. Using these strong colours in the foreground makes everything else drop back into the distance, but make sure you leave some undercolours visible.

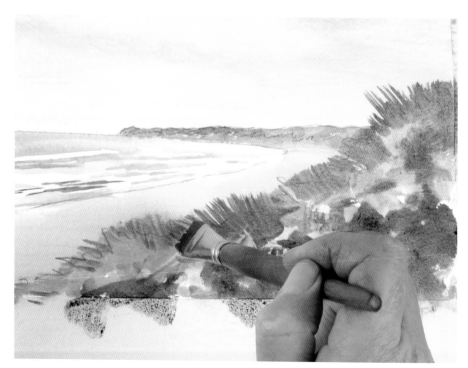

Step 9

Keep building up the foreground using the side of the brush to tap on a darkish mix of cobalt blue and a little burnt sienna. Now for some fun: use your fingernails to scratch and scrape away the wet paint, to give the impression of rough grass and make sense of the mess in the foreground.

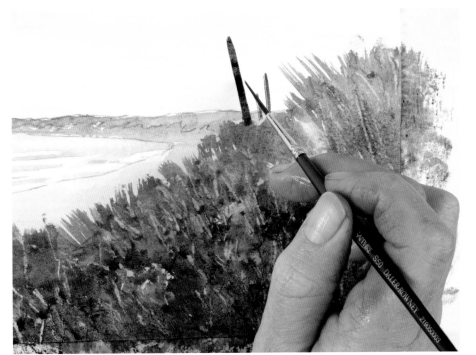

Step 10

To finish off, add a few posts along the top of the foreground ridge using a No. 3 rigger brush and a dark mix of ultramarine and burnt sienna. Switch to the wash brush with a diluted version of the mix for a few squiggles along the edge of the beach, then use the rigger to flick in a few seagulls, this time with the mix almost black.

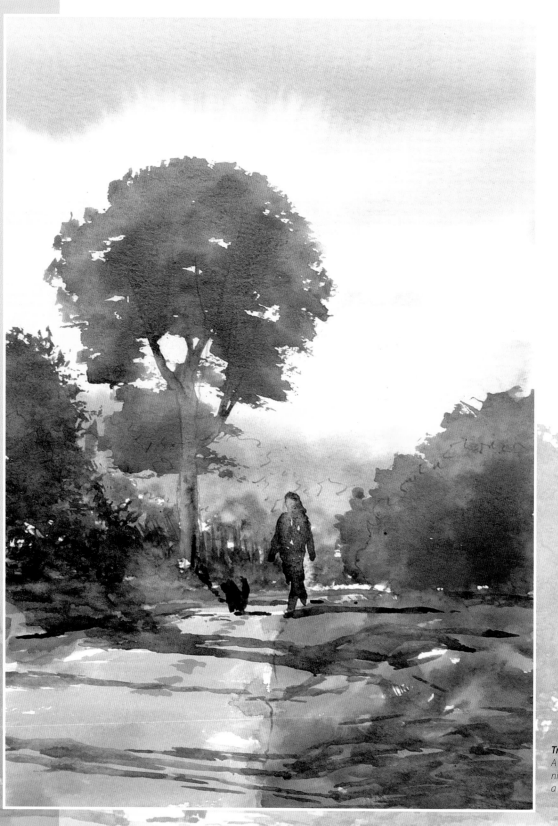

Trees and foliage
A woodland walk always makes a
nice painting – and the figure gives
a sense of scale to the whole picture.

TREES AND FOLIAGE

If you live inland you'll need to make a journey to paint the sea, as in the last project, but no one is ever far from a tree. In this section we're going to look at autumn and summer trees, when the leaf canopy is at its strongest – and there's an extra small project that concentrates on the bare, stark outlines of winter trees.

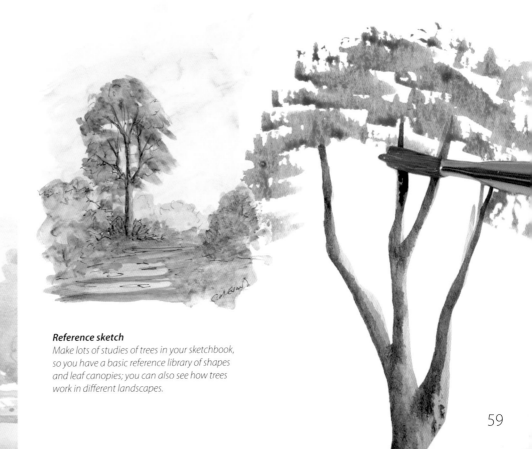

Reference sketch
Make lots of studies of trees in your sketchbook, so you have a basic reference library of shapes and leaf canopies; you can also see how trees work in different landscapes.

59

Autumn trees

1 Start the trunks and main branches with yellow ochre applied with a No. 3 rigger brush. Work quickly and roughly, and don't think about detail at this stage. The light is coming from the right, so the shadows will be on the left ...

2 ... and these are done with a mix of ultramarine and light red on the wet ochre so the edges blend softly and give a rounded look. Go over the shadows where they take up a lot of the trunks and branches, but leave some of the yellow showing through.

3 Make up a darker mix of the shadow colour and use the rigger to flick on some twigs, mainly coming out from the trunk. Don't forget to dab on a few burrs on the trunks – but, as with the twigs, don't overdo the effect.

4 Let everything dry, then load a 19mm (¾in) wash brush with yellow ochre and get ready for some fun: hold the brush like a decorator's brush, not a pencil, and tap the flat of the brush on to the top parts of the branches to give some leaf cover. If you're pushing the bristles hard on to the paper, you should hear the metal ferrule slap down on it.

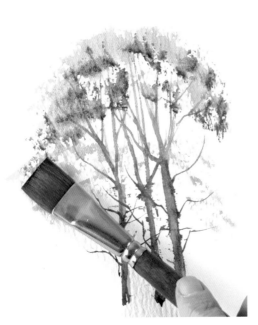

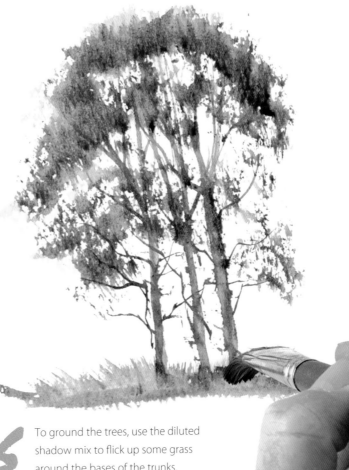

5 While the yellow ochre is wet, do the same with some burnt sienna, and then with the shadow mix, each time making sure that the earlier washes can be seen.

6 To ground the trees, use the diluted shadow mix to flick up some grass around the bases of the trunks.

61

Summer trees

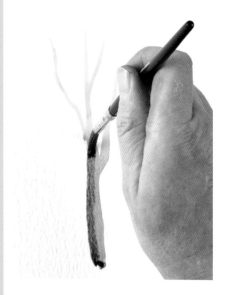

1 Start the trunk as you did for the autumn trees on the previous pages, using yellow ochre and a No. 8 round brush to give a broad, rough outline. While the ochre is wet, add some raw umber on the left, allowing the edges to blend.

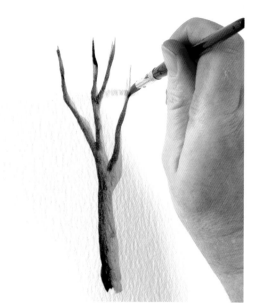

2 You can get an even more rounded feel on the trunk and branches by going over the wet umber with a mix of ultramarine and burnt sienna, again letting the colours blend and soften. On the lower part of the trunk, flick in a few twigs and burrs with a No. 3 rigger brush and the ultramarine and burnt sienna mix.

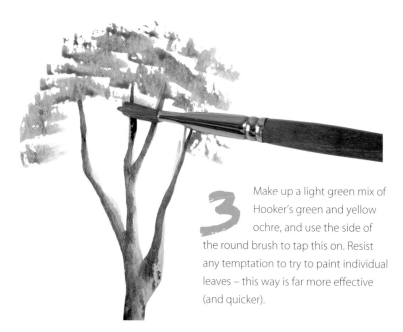

3 Make up a light green mix of Hooker's green and yellow ochre, and use the side of the round brush to tap this on. Resist any temptation to try to paint individual leaves – this way is far more effective (and quicker).

4 While the first green is still wet, make up a darker green mix of Hooker's green and burnt sienna and tap this on in the same way, not forgetting the leaves on the twigs lower down. Leave some of the first green to show through, and don't forget to leave some gaps in the canopy.

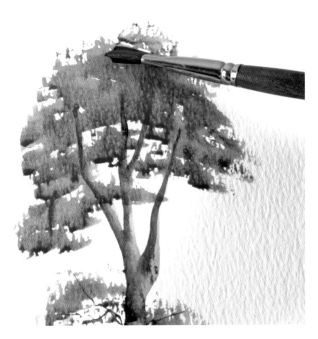

5 Tap on some ultramarine for the shadows in the foliage while the green washes are wet – you can make these quite dark in places. Then use a lighter wash of ultramarine to block in and flick up some grasses to ground the tree in the earth. Hey presto! You have a quickly and cleverly painted summer tree.

SUNDAY PAINTING (1)

yellow ochre

ultramarine

burnt sienna

Hooker's green

raw umber

alizarin crimson

light red

In this nice, simple little scene I've opted for a portrait (upright) format, which emphasizes the height of the main tree in the middle ground. This painting combines the techniques used for foliage in the Saturday exercises with the quick methods for painting skies and land.

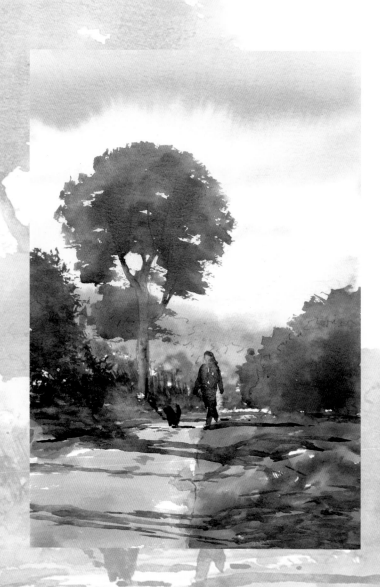

Preliminary drawing

Once again, the drawing is kept very simple, and is really no more than a framework for the paint. Note how the bushes get smaller as they go round the corner. I haven't drawn any of the canopy of foliage on the main tree, just the outline structure of the trunk and boughs.

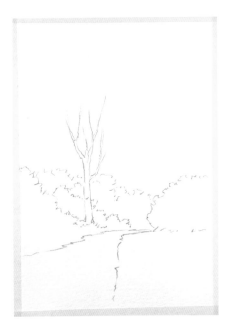

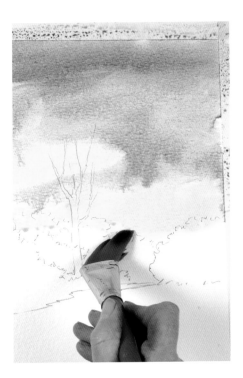

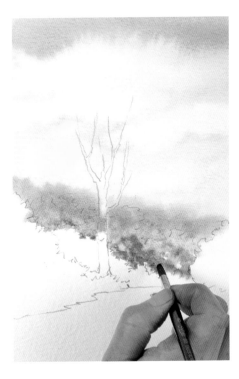

Step 1

Wet the sky area with clean water, then drop in well-diluted yellow ochre on the bottom third using a 38mm (1½in) wash brush. While this is wet, drop in a strong wash of ultramarine from the top, blending into the ochre. Squeeze out the brush and suck the colour out of the clouds and the area where the sky meets the trees.

Step 2

While the sky is still wet, put in the distant trees with a No. 8 round brush and a mix of ultramarine and burnt sienna; then quickly drop over this a mix of Hooker's green and burnt sienna to give a nice effect of distance. Let this dry a little.

Step 3

Now add some yellow ochre and then burnt sienna underneath it to warm up the entire area. While these washes are wet, put in a slightly darker mix of Hooker's green and burnt sienna to create a melée of bushy growth. Add some more burnt sienna and then some touches of ultramarine to the bushes.

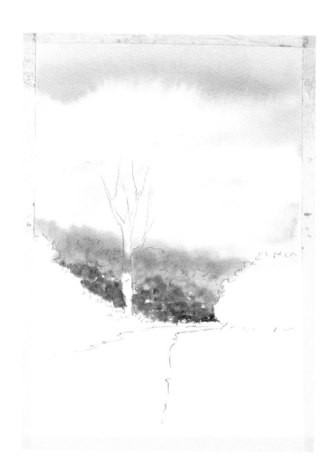

Step 4

Don't worry if some of the sky and bush washes have gone over the outlines and on to the tree trunk, as you can correct this even on dry paper. Simply wet and then squeeze out a 19mm (¾in) wash brush and use the damp tip to suck the colours out of the paper. Let it dry, and then on you go.

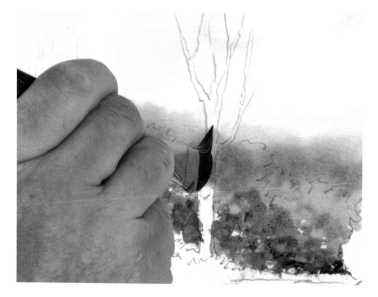

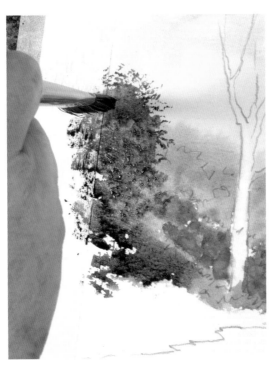

Step 5

For the big bush on the left, load the 19mm (¾in) wash brush with yellow ochre and tap the bristles on to get a ragged edge. Follow this with a mix of Hooker's green, burnt sienna and ultramarine, allowing some of the yellow to show through. 'Split' the brush by mashing it down into the mix on the palette, and stipple on the leafy edges of the bush.

Step 6

While the bush is drying, switch to the No. 8 round brush to put a touch of yellow ochre on the left side of the main tree. While this is wet, add some raw umber on the right, letting the colours merge together, and follow this with a mix of ultramarine and burnt sienna to give a rounded effect.

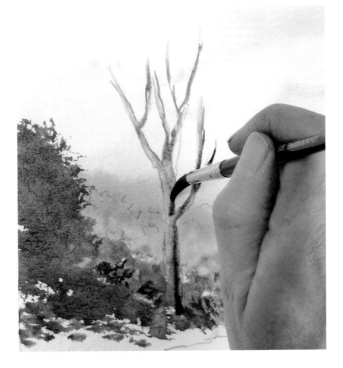

Step 7

Start the foliage by tapping on yellow ochre with the side of the round brush. While this is wet, tap on a watery mix of Hooker's green and burnt sienna – allow the yellow to show through in places, and remember to leave gaps in the foliage. For the shadow areas of the leaves, drop in some ultramarine and burnt sienna.

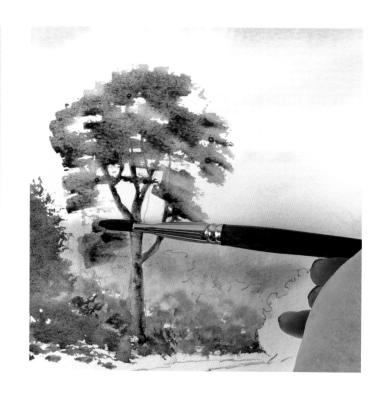

Step 8

Use the side of the 19mm (¾in) wash brush to dab on yellow ochre for the bush on the right, then follow this with the same colours as for the left-hand bush, stippling around the edges. This bush is in much more shadow, so drop in a deepish mix of ultramarine, alizarin crimson and burnt sienna for this.

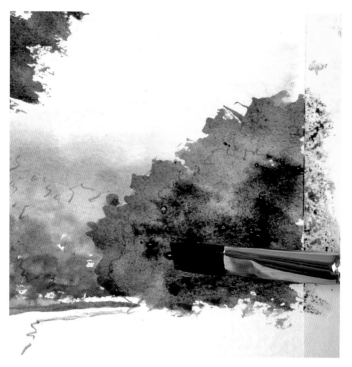

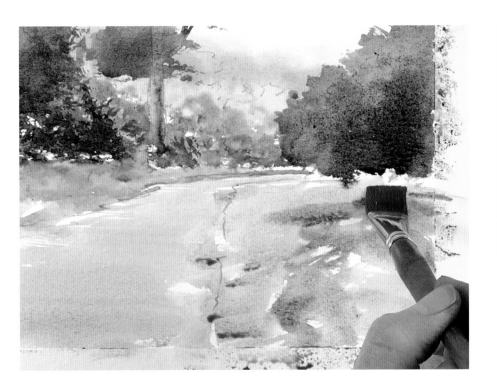

Step 9

Block in the sides of the path with yellow ochre, then use a mix of yellow and light red for the path itself, working quickly and loosely. Dab a mix of Hooker's green on to the yellow earth while it is wet, and put some daubs into the middle of the path for grass tufts. Leave all this to settle for a few seconds, then add a darker mix of the green for the shadows on both sides of the path. Let everything dry completely.

Step 10

Use the No. 8 brush to lift off paint for the figure as in step 4, but don't go right back to white paper. When it's dry, dab on an ultramarine and burnt sienna mix for the hair. The face is a mix of alizarin crimson, yellow ochre and a touch of ultramarine, the coat is straight alizarin crimson, and the legs a mix of ultramarine and burnt sienna. Put in the shape of the dog with burnt sienna and raw umber, with dark ultramarine and burnt sienna mixed for the 'black'. Finish with shadows in ultramarine, alizarin crimson and burnt sienna, following the contours of the path and banks – and add some for trees that are outside the scene but still casting shadows.

TREES AND FOLIAGE 69

SUNDAY PAINTING (2)

yellow ochre

ultramarine

burnt sienna

As a contrast to the preceding Sunday painting, this winter scene has no leaves or rich colours – you just have to concentrate on the shapes of the trunks and branches, and paint the background trees as a mass. This is a very simple painting, so don't spend time fiddling about with it: keep it loose.

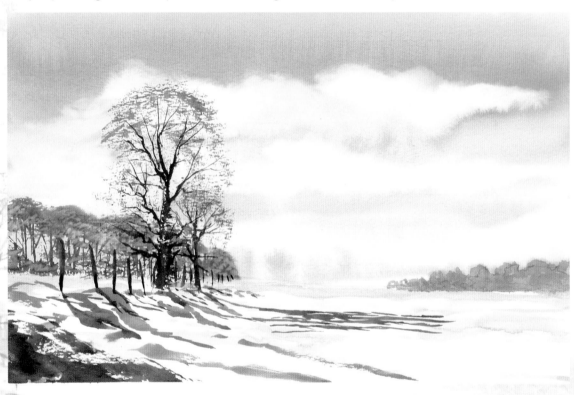

Preliminary drawing

The simple outlines take in the whole scene: far distant trees on the right, a clump of trees to the left in the middle distance, and two foreground trees, one slightly further away and therefore smaller. And that's all there is to it.

Step 1

Wet the sky, then use a 38mm (1½in) wash brush with a mix of yellow ochre and burnt sienna in the bottom third, and watery ultramarine for the rest. Suck out the clouds with a squeezed-out brush. While this is damp, use a No. 8 round brush for the distant trees using a mix of ultramarine and burnt sienna; use a stronger mix and a 19mm (¾in) wash brush to tap on the trees in the middle distance. Flick in their bases.

Step 2

Use a No. 3 rigger brush and the same mix for the further foreground tree – just a few squiggly lines that let the paper show through. For the nearer tree use a stronger mix, laying on the side of the brush and stroking through. Add a few boughs and twigs with the rigger, then use the wash brush to tap on the smallest twigs, still working very dark.

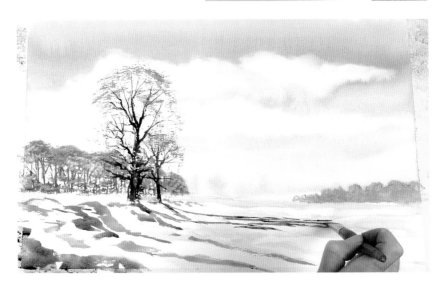

Step 3

To tint the contours of the snow, use the same wash very, very weak, again working with the wash brush; then strengthen the mix a little for the shadow areas, and build this up for the shadows cast over the snow by the trees. Increase the strength of the mix to almost black for the fence posts, which give a sense of recession. Simple – and how few colours you've used!

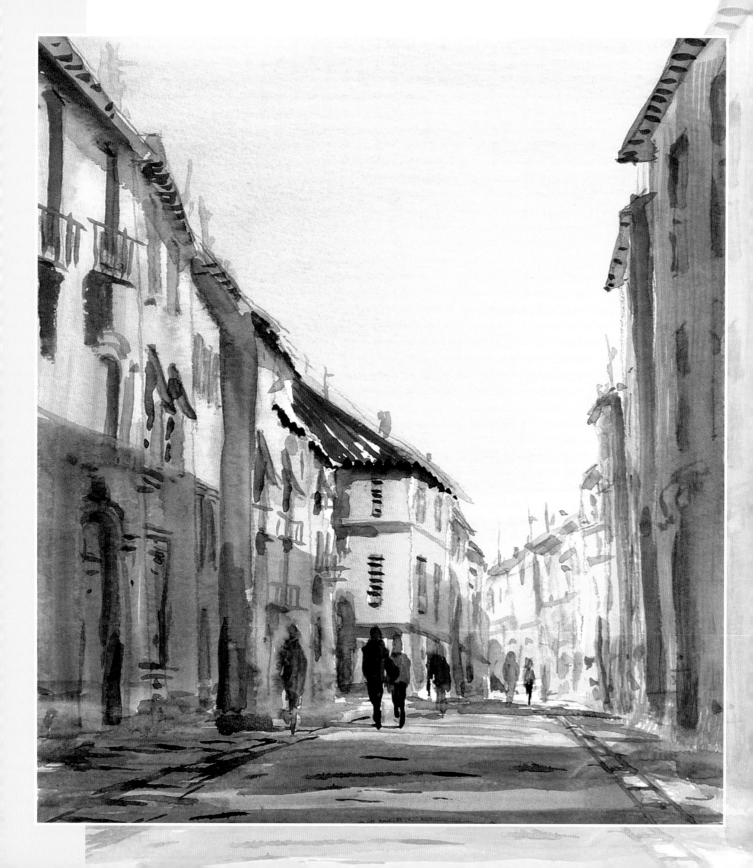

BUILDINGS

Street scenes and buildings often seem daunting – and terms such as 'perspective' and 'vanishing point' only increase the fear factor. But a few exercises will help you create effective perspective and shapes, and knowing how to add textures will take your paintings further.

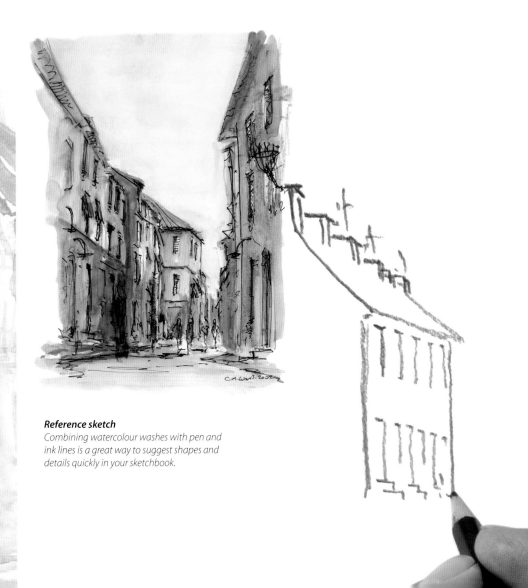

Reference sketch
Combining watercolour washes with pen and ink lines is a great way to suggest shapes and details quickly in your sketchbook.

Street scene
The lines of the roofs and the kerb take the eye to the centre of the painting, where the red roof, pink walls and figures are the focal points.

Basic shapes and perspective

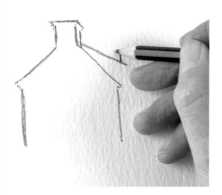

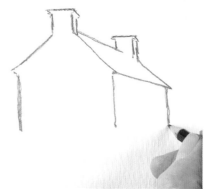

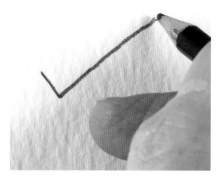

1 For a cottage, draw the side wall and chimney. Draw a diagonal line from the top of the chimney and show the front, then use the same angle to draw the ridge of the roof.

2 Draw the far chimney and sloping edge of the roof at the same angles only smaller, as they are further away, then join the two roof lines.

3 A simple tick is all you need to draw windows, doors and ledges. Following the roof line, put the tick on its end for windows and doors, and on its side for ledges.

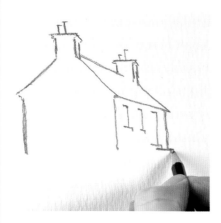

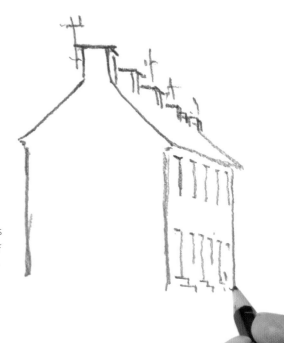

4 Without adding much detail, you can create an effective building at an angle by just following the basic guidelines.

5 To draw a row of buildings, work in the same way, adding more sets of chimneys before joining up the top roof line, each one getting smaller as it goes away from you.

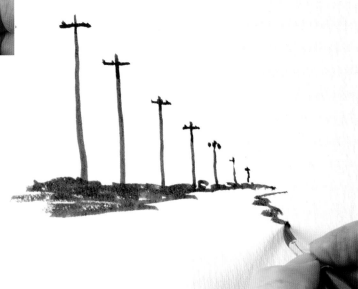

1 We've already looked at recession in the landscape; here's how to make it work without needing to use colour. Paint a row of telegraph poles that get progressively smaller as they go into the distance. Make sure the upright angles are the same, and keep the diagonal of the tops straight.

2 Now add the ground at the base of the poles, keeping this horizontal like the crossbars. Add the bank at the other side of the path with a squiggly line, remembering that the road will appear narrower as it runs into the distance.

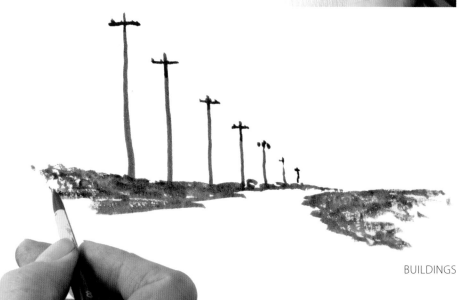

3 A little bit of blocking in adds contours to the path, and there you are – a simple country lane that has a great sense of distance and space.

Textures

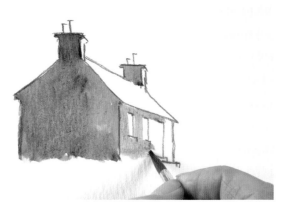

1 Using the drawing of a cottage from the previous pages, block in the side and far chimney with raw umber; dilute this for the front, which is facing the light.

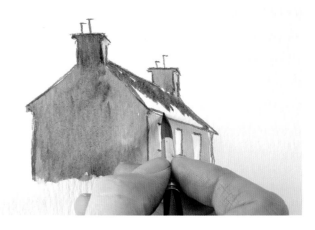

2 Mix ultramarine with burnt sienna for the roof and stroke it on following the diagonal angle and leaving a little white paper showing through for variation – roofs aren't all one colour.

3 For the bricks or stonework on the side of the building, mix raw umber with ultramarine and use the edge of a wash brush to stipple this on. Vary the strength of the mix and don't try to put in too many details – leave the original colour to show through, and remember that watercolour washes dry about 50 per cent lighter than when applied.

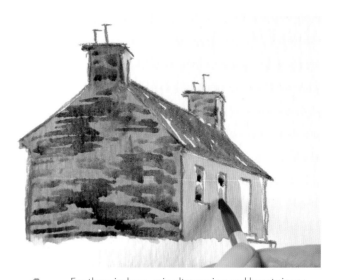

4 For the windows, mix ultramarine and burnt sienna darker than for the roof and use the tip of a round brush to dot in a couple of touches, leaving white between them for the window bars. Change colour and do the same for the door, which again isn't a flat colour.

1 To add texture to stonework, start by stippling on a first colour – I used sand – with a wash brush. Vary the strength of this wash to show the edges of the stones, but don't go into detail here.

2 Mix the sand colour with raw umber and stipple this on top of the wet wash in the same way, leaving some of the base wash showing through. It's all a bit of a mess at this stage.

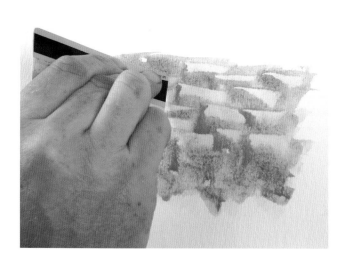

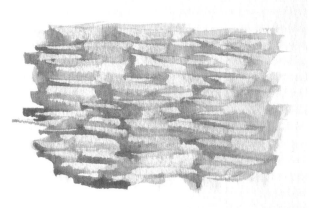

3 While the washes are wet, use the edge of a credit card to scrape them off to create stone shapes. Work in the same direction each time to reflect the directional light.

4 For smaller stones or rocks, you can cut up the credit card into smaller pieces – which will also save you money!

SUNDAY PAINTING

Here's a simple street scene in Lucca, a lovely town in Tuscany. The buildings are old and not all of the same height, so you have to treat each one separately and use the kerbs to provide the perspective lines. On the other hand, just a few details can bring the scene to life – and they aren't difficult to do.

cobalt blue

yellow ochre

light red

Hooker's green

cadmium red

alizarin crimson

burnt sienna

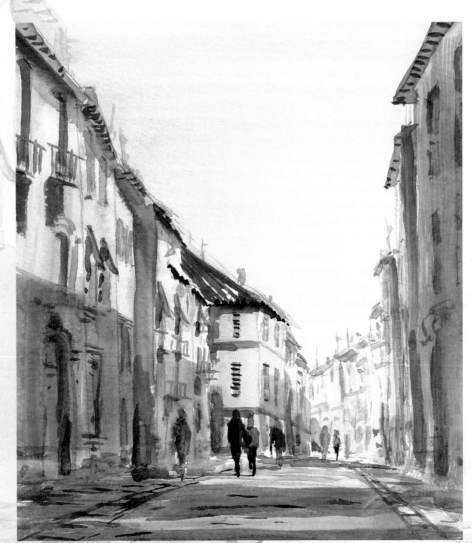

Preliminary drawing

This is a slightly more complex drawing than in the previous projects, but it's still just the outlines, using ticks for the windows, doors and shutters. I sketched in the figures to give a sense of scale from the start, and decided to leave the sky as a plain flat wash so it wouldn't detract from the buildings beneath.

Step 1

Wet the sky area with clean water, and use a 38mm (1½in) wash brush to block in the sky with cobalt blue. Squeeze out the brush and suck out any paint over the buildings – any that's left will add a sense of recession. Let this dry.

Step 2

Start the buidings in the same way, wetting them with clean water and then dropping in a watery wash of yellow ochre with a 19mm (¾in) wash brush. While this is wet, add a little light red, letting the colours run into each other.

Step 3

Mix light red and yellow ochre for the foreground building on the right – only a few strokes are needed. While the wash is wet, drop in some simple blobs and lines of cobalt blue, following the shapes and lines of the buildings. Let everything dry before starting to make sense of this lovely mess.

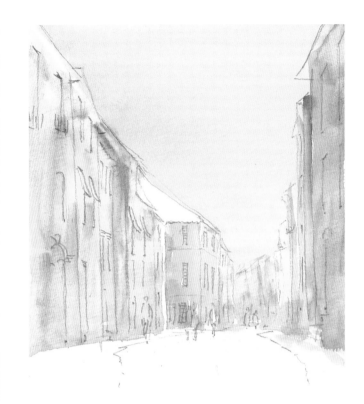

Step 4

Switch to a No. 8 round brush to block in the prominent roof in the middle distance with light red, being careful not to go over the buildings in front. Use a much weaker wash for the smaller front of the further roof, which can only just be seen, and even more watery washes for the roofs in the far distance.

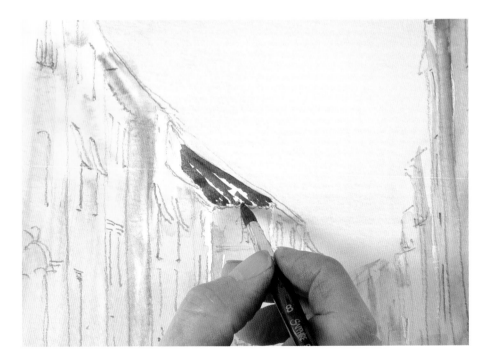

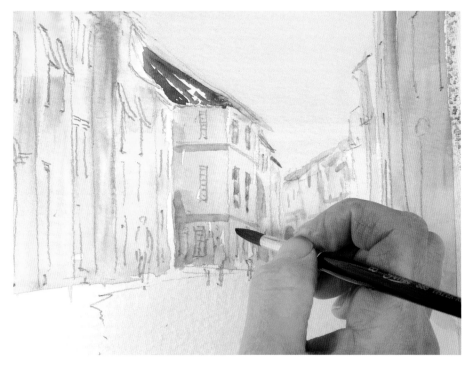

Step 5

Using a watery mix of light red and a little cobalt blue, put some tiny intimations of detail into the furthest buildings, without being too complicated. Come forward to the buildings in the middle distance and use a slightly stronger wash to paint the windows with three blobs, leaving lines between for the window frames. Use an even stronger wash for the windows in the foreground. Remember to keep everything simple.

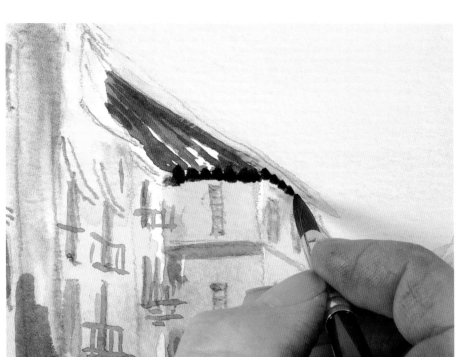

Step 6

Add a few hints of balconies using the same wash with a little more cobalt blue – all you need is a few lines for the bars and rails; let the eye fill in the rest from these impressions. Add more light red for some warm shadows here and there, particularly in the red roof, but leave a little white showing. Make up a dark shadow mix from cobalt blue, alizarin crimson and burnt sienna, and drop in blobs for the underside of the pantiled roof, then join them up.

Step 7

Add the shutters on the central building with the dark shadow mix – again, you're just hinting at what's there, rather than trying to paint in every detail. Use a diluted version of this mix for the lighter shadows throughout the buildings, adding more water the further into the distance you go.

Step 8

For the upper window canopies on the left side use just one quick stroke of Hooker's green, and do the same for a couple of red canopies below with cadmium red. Return to the watery dark shadow mix for the underhangs below the canopies – look how easily little dibs and dabs with the brush can build up the scene and convey the character of this historic old town. Use a mix of light red and cobalt blue for the shadows and roof underhangs of the foreground buildings.

Step 9

Touch in a little colour on the distant roofs with a watery mix of light red and alizarin crimson, still leaving some white showing. Then use the cobalt blue and light red mix for a few chimneys and aerials above the roofs. Stroke a watery version of this mix over the ground with the smaller wash brush, add a little light red while it's wet, and use a mix of cobalt blue and alizarin crimson to give the impression of a few kerb lines.

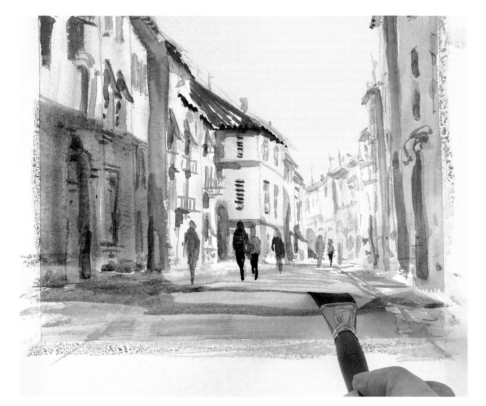

Step 10

Let the picture dry a bit, then add a few people with the No. 8 brush – note how a little cadmium red in the coat of the furthest figure draws the eye into the distance. To get more light into the scene, you need to put in more dark: very quickly stroke a very watery mix of cobalt blue and alizarin crimson with a little burnt sienna on to the left-hand foreground buildings, then bring this across the street – remember to indicate the kerbs with the shadow mix. And there you have it: a classic Italian street scene.

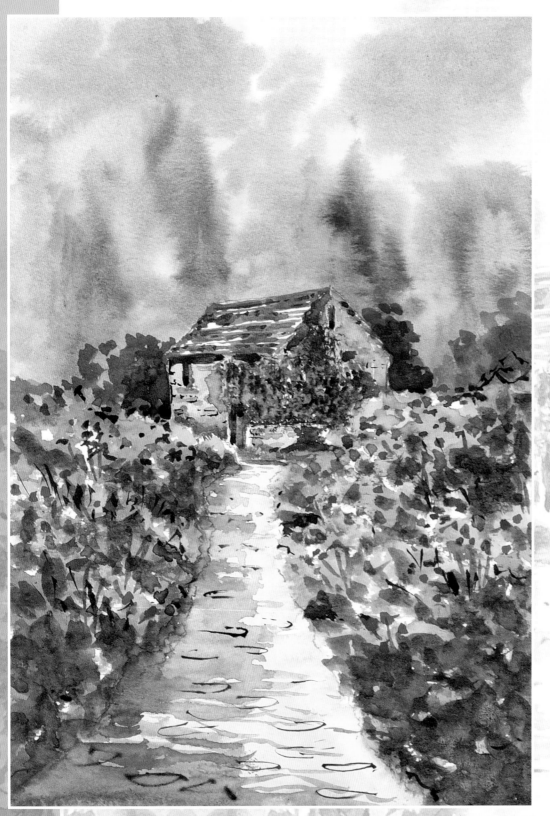

Flowers
Bright blooms simply dotted on bring life to this scene of a path leading to an outbuilding.

FLOWERS

Painting flowers is a great way to build up confidence – you can use really strong colours for some blooms, and you don't have to go into much detail for an effective impression. The Saturday techniques for this project – wet into wet, green leaves, lifting out and finishing touches – have been combined into a single set of exercises, although you can practise them one by one.

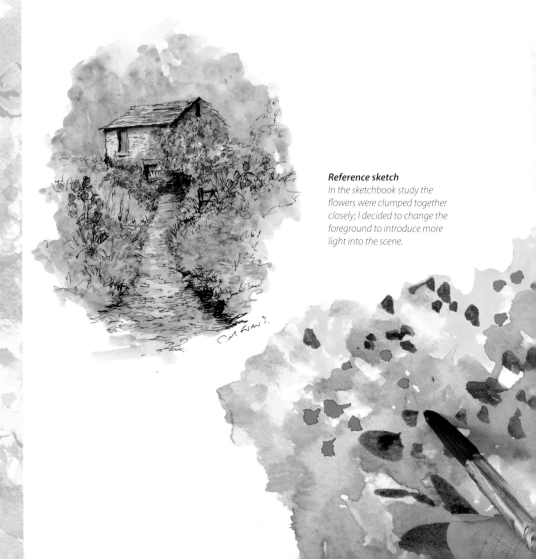

Reference sketch
In the sketchbook study the flowers were clumped together closely; I decided to change the foreground to introduce more light into the scene.

Wet into wet

1 Wet the area of the flowers with clean water, then drop in a watery wash of cadmium yellow here and there; don't try to cover the whole of the wet area, and allow the colour to spread loosely.

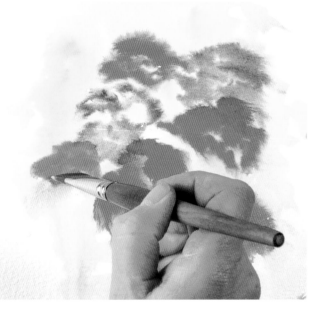

2 Working quickly, drop in some ultramarine – allow the yellow wash to show through. I used a 19mm (¾in) wash brush, which is broad enough to make largish marks.

3 Drop in cadmium red and then cadmium yellow mixed with cadmium red for more blooms, again letting the colours blend into each other and creating soft edges.

Green leaves

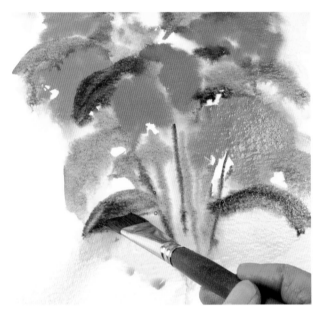

1 While the washes are still wet, add the first green mix of Hooker's green and yellow ochre – this is just to make the basic shapes of the leaves and stems. Keep the edges soft at this point and concentrate on working quickly. Use a mix of Hooker's green and burnt sienna to add a darker green for the foreground leaves and the stems (using the edge of the brush); this mix should blend with, but not obscure, the first green wash.

2 For the shadowed areas and veins use a mix of ultramarine, Hooker's green and burnt sienna, and vary the strength to pick out a few first details. At this stage the picture is a mass – you might say mess – of strong colours, with not much differentiation between the lightest and darkest parts.

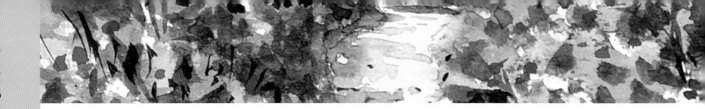

Lifting out paint

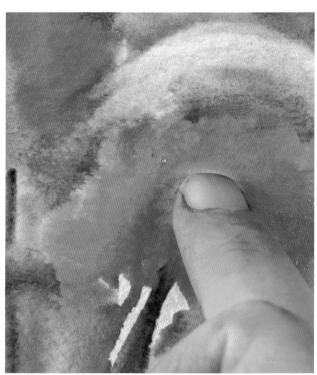

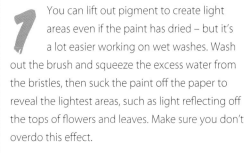 You can lift out pigment to create light areas even if the paint has dried – but it's a lot easier working on wet washes. Wash out the brush and squeeze the excess water from the bristles, then suck the paint off the paper to reveal the lightest areas, such as light reflecting off the tops of flowers and leaves. Make sure you don't overdo this effect.

2 To take off and lift out small areas of paint, such as in the middle of a bloom, without going all the way back to the white of the paper, use a dry finger – you have a surprising amount of control over the paint this way.

Finishing touches

1 Details and finishing touches are best added with a No. 8 round brush. Use the tip to put in mixes of ultramarine and burnt sienna: watery washes for shadows under the leaves ...

2 ... and stronger washes for a very few defining outlines. You don't need any more than this.

SUNDAY PAINTING

This is an outbuilding in the garden of John Ruskin's house in the English Lake District. I like the way the bright borders frame the path that leads to the building, with just a hint of trees and woodland in the distance. To get this effect you need quite a few colours – I used 11 – and the mixes can range from direct and vibrant to quite subtle and understated.

cadmium yellow

ultramarine

sand

burnt sienna

raw umber

yellow ochre

Hooker's green

alizarin crimson

light red

cobalt blue

cadmium red

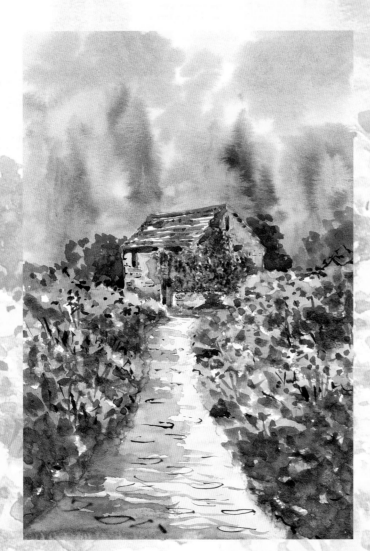

Preliminary drawing

The outline here is intended to do nothing more than fix the position and proportions of the building, lane and borders – everything else will be done by the watercolours. Using the portrait format accentuates the feeling of height and leads the eye along the lane.

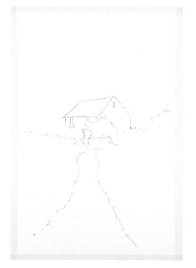

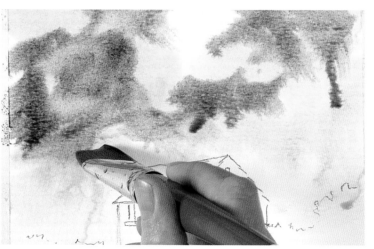

Step 1

The top of the scene is not so much a sky wash as a background colour. Start by wetting the area with a lot of clean water, then drop in cadmium yellow with a 38mm (1½in) flat wash brush. While this is wet add ultramarine, working up to the building and borders; use a stronger ultramarine wash to suggest trees in the distance.

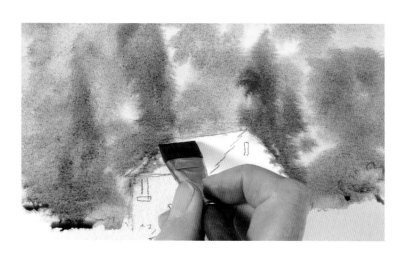

Step 2

Wet and squeeze out a 19mm (¾in) wash brush, and lift out some of the washes to provide some variety. Continue to add the yellow and ultramarine washes, being careful not to overwork what should be a simple, quick background. Let everything dry completely.

Step 3

With the same brush and a mix of sand and ultramarine, paint the building the unusual Lakeland stone colour (if you can't get the sand colour, try yellow ochre mixed with a tiny bit of raw umber). Block in the walls, working around the door, windows and ivy, and while this wash is wet drop in a few warm touches of burnt sienna from a No. 8 round brush, letting the colours soften as they run together.

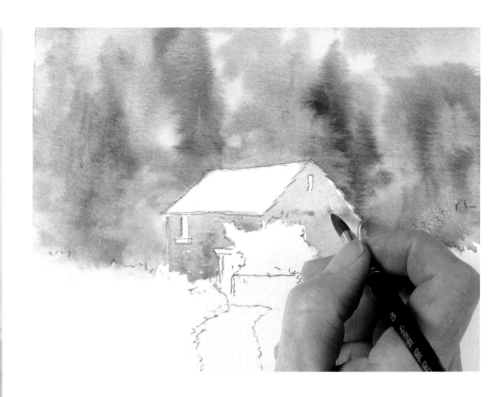

Step 4

Work along the direction of the roof with long strokes of burnt sienna; let some white paper remain to give the effect of light hitting the roof tiles. Fill in the windows and door with a mix of raw umber and burnt sienna, and use sand and raw umber for the sills plus a bit more variety in the stonework and a little on the roof.

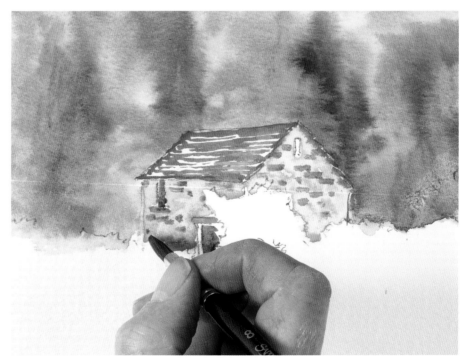

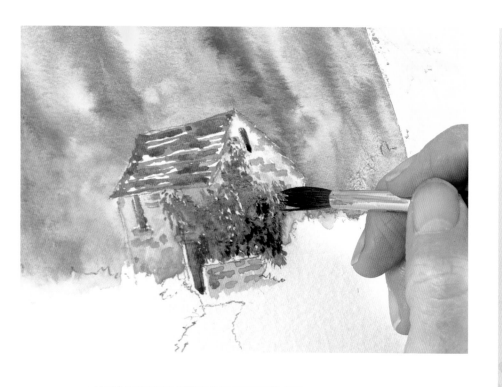

Step 5

To start the ivy, 'split' the No. 8 brush as described on page 67 and stipple on a watery wash of yellow ochre, followed by darker washes of Hooker's green and burnt sienna, and ultramarine and burnt sienna. Allow these to dry a little, then add the shadows, starting with a weak mix of ultramarine, alizarin crimson and a touch of burnt sienna on the right side. Strengthen the mix for the harder-edged shadows on the building and wall.

Step 6

For the big splodgy areas in the borders drop in a few blobs of cadmium yellow, then a very watery ultramarine wash. Working quickly, follow this with a mix of Hooker's green and yellow ochre – just slap it on and make a mess – then do the same on the other border. Let everything dry a little.

Step 7

The path should be bright and fairly flat, to contrast with the flowers in the borders: lightly stroke on a mix of yellow ochre and light red with the smaller wash brush. While this is wet add a few undulations in a stronger mix, this time using the edge of the brush.

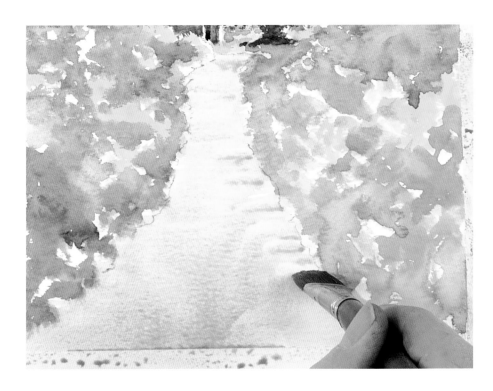

Step 8

Now for the flowers. Using the No. 8 brush, stipple on a very strong wash of alizarin crimson – don't go mad and put too much in any one area, just a few dots here and there. Then do the same with cobalt blue.

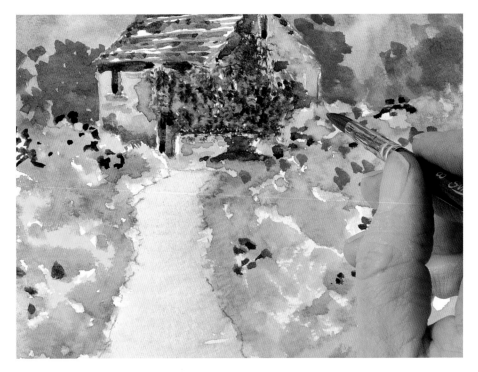

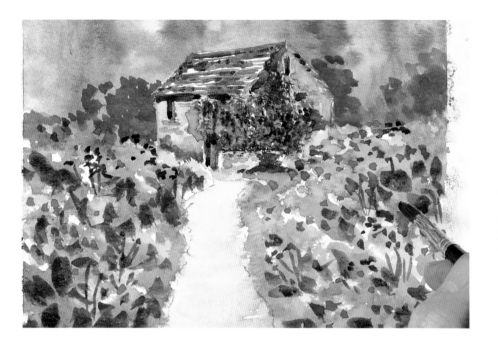

Step 9

Next add strong cadmium yellow and a few touches of cadmium red – less is more here, remember, and it's better to have a few blooms standing out than a mass of indistinguishable ones. Use a mix of Hooker's green and burnt sienna to add a few simple blobs for leaves and lines for stems; make these a bit darker in the foreground. Let this dry a little.

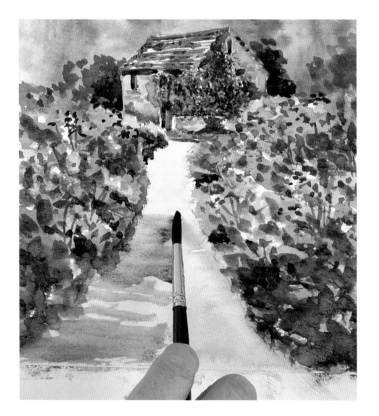

Step 10

Mix ultramarine, alizarin crimson and a little burnt sienna for the shadow areas, and start by adding shadows to the bushes near the building – soften the edges to make the building stand out. Use the same mix for the border on the left, bringing the shadow at its foot across the path, and a lot less in the right border, which is in sunshine. Make a very dark mix of ultramarine and burnt sienna, and use a No. 3 rigger brush to add a few squiggly marks and lines to the path and borders to pull everything together. That's it – and you haven't painted a single flower in detail!

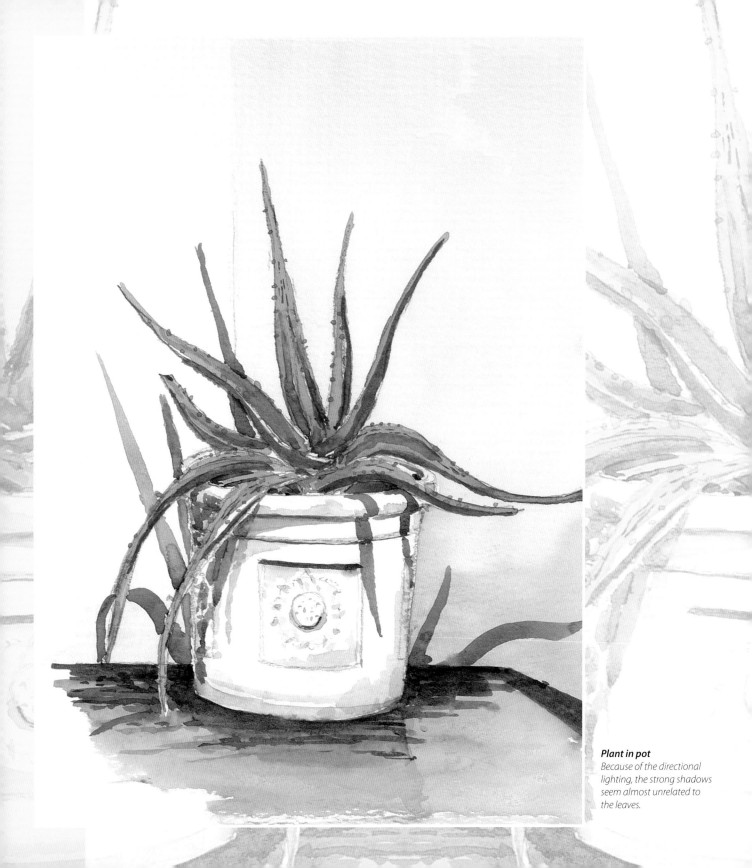

Plant in pot
Because of the directional lighting, the strong shadows seem almost unrelated to the leaves.

STILL LIFE

The good thing about still lifes is that you don't have to go far to paint one – just set it up and enjoy it. However, while you do have total control over your subject, you also have to think hard about how to compose a picture and, particularly, how to get the lighting right: the Saturday exercises for this project are designed to give you some guidelines.

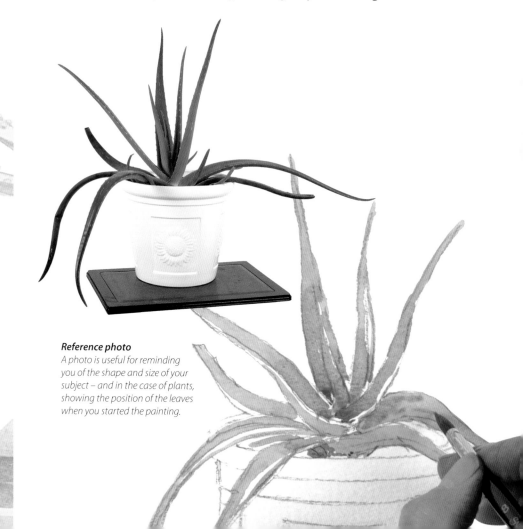

Reference photo
A photo is useful for reminding you of the shape and size of your subject – and in the case of plants, showing the position of the leaves when you started the painting.

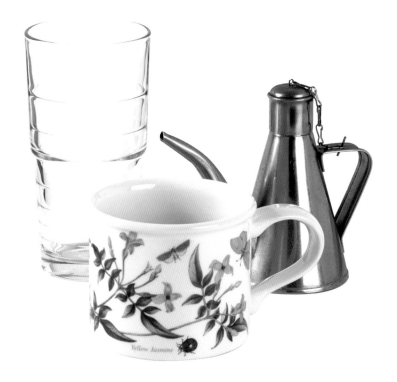

Setting up and composition

The three objects shown here were the first that came to hand in my kitchen, but they turned out to be a good choice: the glass is tall and transparent, the metal olive oil can is shorter and reflective, and the mug, although white, has a lot of colour on it. Before you even think of drawing or picking up a brush, you need to spend time trying out different positions and placings.

In the setting at right, although you can see all three objects clearly, the overall effect is pretty boring – not least because the mug and oil can are facing the same way, with their handles on the left. There's no link between the three as there is in the setting above, where the mug blocks out part of the other two objects; however, the spout of the can appears to be floating in mid-air, thanks to the white of the mug lip.

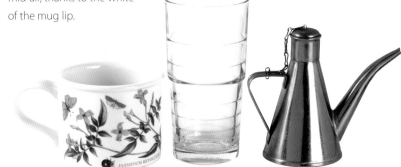

Bringing the can to the front, as shown on this page, solves the problem of the disembodied spout, but the metal now blocks off the colour on the mug.

As you can see from these few examples, there is no one right way to compose a still life, but some settings do look more attractive than others. Make lots of drawings – just the rough outlines with no detail – to see how your subjects fit together in a composition, and experiment with the format you want to use: landscape (horizontal) or portrait (vertical) are the most used, but consider a square frame for your picture as well.

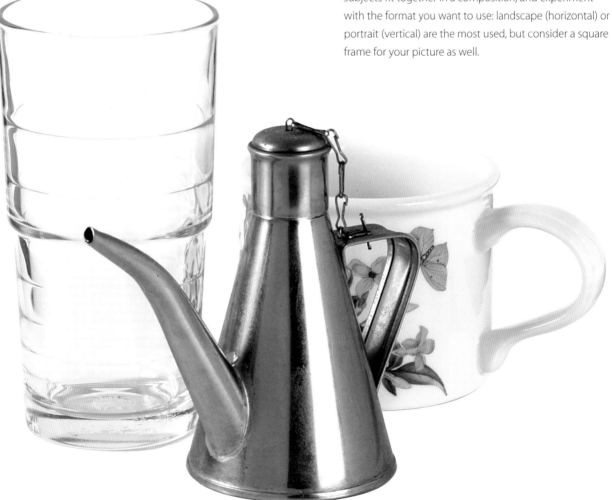

STILL LIFE

Lighting and shadow colours

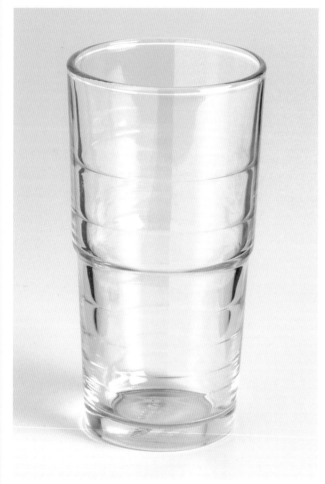

Below, the light from the right is very strong, producing a shadow that is darker than the glass itself. The single diffused reflection in the example on the left has been replaced by two sharp ones, and the indentations around the glass towards the base are more visible.

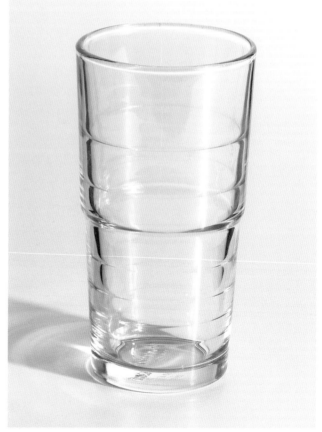

I used a glass for this section to show how a highly reflective surface is affected by light. In the photo above the light is coming from the right but only faintly: there is only a little cast shadow from the glass, but quite a strong one inside it.

With no directional light, as on the right, the glass can be seen in more detail, but the reflections have been lost, except at the base. It looks more 'solid' like this.

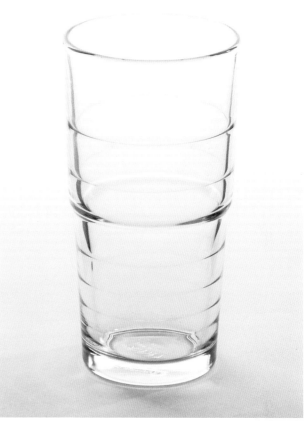

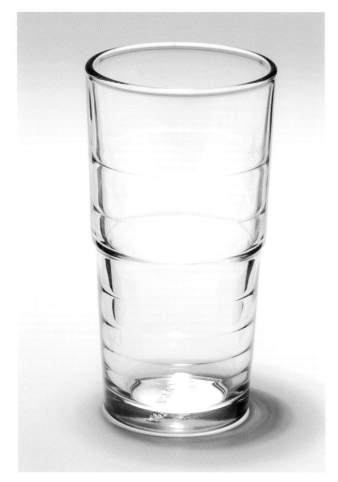

Here the light is coming from directly above the glass, and is reflected strongly back up from the base – the resulting oval is diffused by the front of the glass and thus distorted. To paint shadows in any of these lighting situations, you need to look at the cool colours of the blues first, mixing them to match the situation.

SUNDAY PAINTING

ultramarine

burnt sienna

yellow ochre

Hooker's green

raw umber

This is a very large aloe vera plant in a decorative pot, which lives in my studio. It may seem as far away from the other subjects in this book as you could get, but if you reduce them all to their basics, they are just a simple matter of shapes, colours and tones. The shadows and table provide areas of colour that make the white pot stand out.

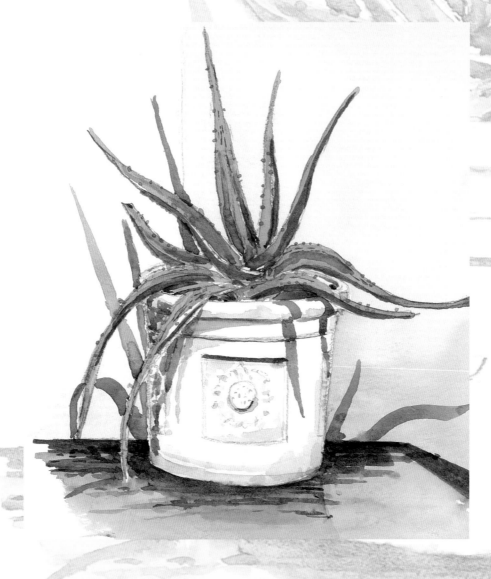

Preliminary drawing

The most important thing in this drawing is to make sure the curves of the pot match accurately. I drew the outlines of the leaves but left the shadows to be painted. From this angle you can just see the inside of the pot – this will be a dark tone that gives a three-dimensional feel to the picture.

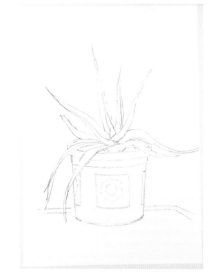

Step 1

The right-hand wall is slightly darker than the other one: use a 19mm (¾in) wash brush and a very watery mix of ultramarine and burnt sienna for this, going over the leaves but around the pot. Add a little shadow on the left wall, and strengthen the mix a little at the base of the right wall, then leave to dry.

Step 2

Switch to a No. 8 round brush to put a mix of quite a lot of yellow ochre and less Hooker's green on the leaves. Block in the colour, with no detail at this stage. The wash is transparent, so you can see the pencil drawing beneath.

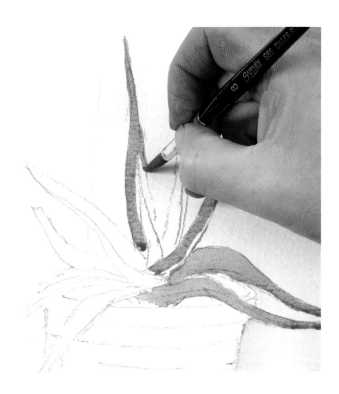

Step 3

While the green is wet drop in a bit more yellow ochre, mainly at the base of the leaves, and let it spread slightly. Allow this to settle, then paint an extremely weak, watery mix of ultramarine and burnt sienna under the lip of the pot and on the inside at the back.

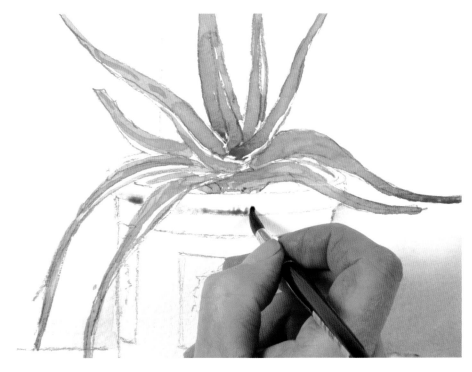

Step 4

Bring the wash down the pot, remembering where the light is coming from, and follow the pencil lines as you add the decoration and the shadows it casts.

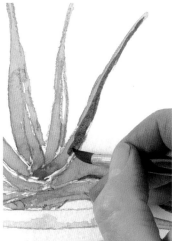

Step 5

Going back to the plant, use a slightly darker mix of Hooker's green and burnt sienna for the undersides of the leaves. You can vary the strength of the mix for variety, and to add depth and direction.

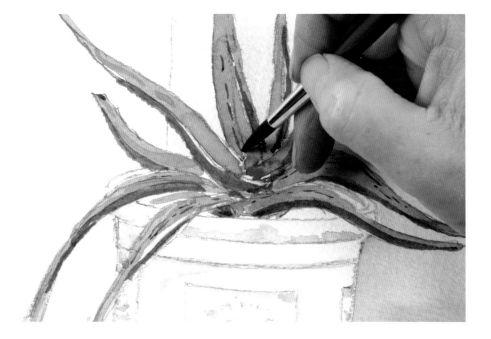

Step 6

Make a stronger version of the mix and use the point of the brush to put texture points and marks on the leaves – don't try to add every single bump, just a few broken lines that suggest more. Stroke on longer lines for the veins.

Step 7

Add more burnt sienna to the mix for the inside of the pot, and darken it quite considerably. Dab on the spines on the edges of the leaves with dots of yellow ochre; again, don't count them all, just add enough to make the effect – if the plant starts to look like a cactus, you've gone too far.

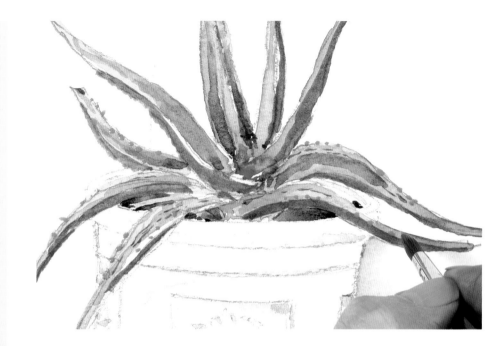

Step 8

Now it's time for some serious shadows on the pot, using a pretty dark mix of burnt sienna and ultramarine. These sharper shadows are cast by the leaves and follow both their curved shapes and the different curvature of the pot. Use a weaker mix to reinforce and strengthen some of the shadows of the decoration.

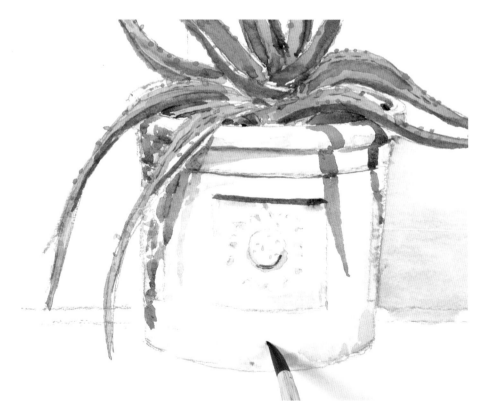

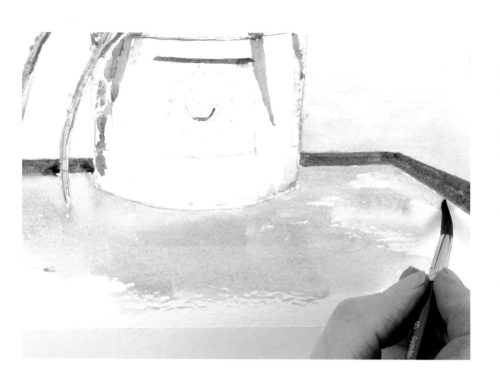

Step 9

The table is included only to provide a base for the subject and to set off the white of the pot, so it doesn't need any detail. Use a mix of raw umber and burnt sienna for the wood, and a watery one of Hooker's green and burnt sienna for the green top. Let everything dry before going on to the final stages.

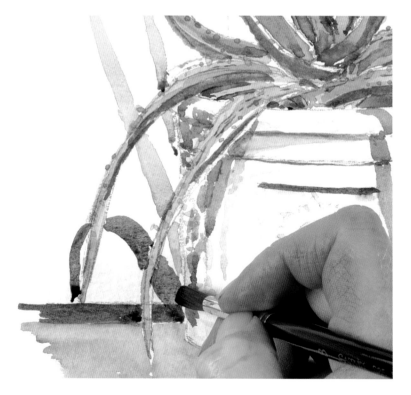

Step 10

Add plenty of water to the dark shadow mix and put some shadows on the wall behind the pot on the left, keeping them fairly dark at the base. Follow these with the shadows cast by the pot on the table, which push the long leaf on the left forward. Move on to the leaf shadows on the right wall – the light source is above and from the front, so the shadows are cast in several directions. Finally put a little shadow at the base of the pot to ground it on the table.

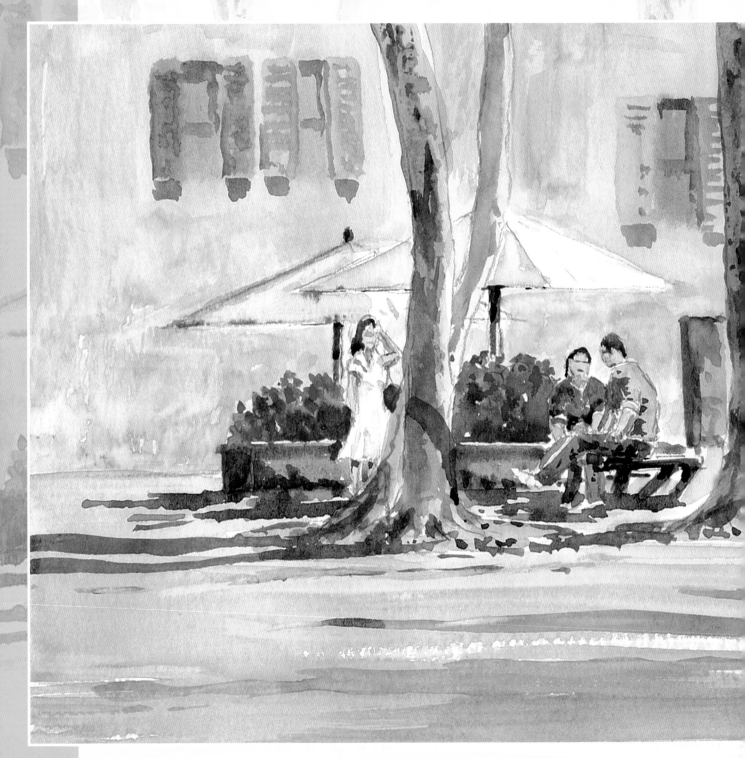

Figures in a town square
The figures here have just enough detail to look complex, but are actually quite simply painted.

FIGURES

How many landscapes do you see where either there are no figures to give a sense of scale and human interest, or they have been added as an afterthought and let everything down? Simple exercises that show how to paint figures, skin tones and clothing will give you the confidence to add them to your pictures.

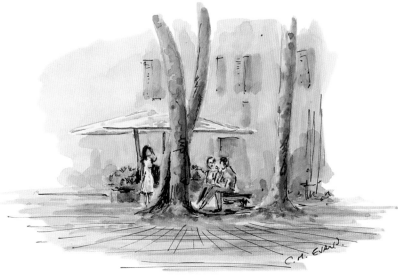

Reference sketch
This quick sketch gave me enough information to work on for the placing of the trees, umbrellas and figures, and I added a little information about how the shadows fell. Note the pen lines in the foreground, which lead the eye into the point of focus.

Skin tones and shading

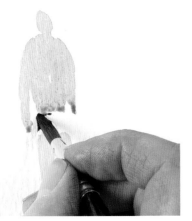

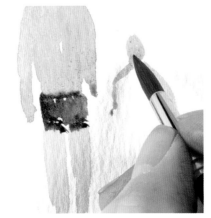

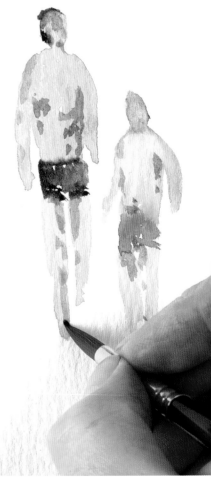

1 Make up a flesh tone from yellow ochre, alizarin crimson and a spot of ultramarine, then paint a blob for the head, a rectangle for the body and sticks for the arms.

2 Use a mix of ultramarine and burnt sienna for the swimming trunks, then the flesh tone for the stick legs. Do the same for the smaller figure of the child.

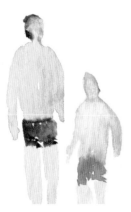

3 While everything is wet add some cadmium red for the child's trunks, and use a lighter mix of ultramarine and burnt sienna to drop in the man's hair.

4 Let the washes dry, then put in some shadows – I added ultramarine to the flesh mix. The light is from the left, so the shadows go on the right.

5 Use the shadows to add contours to the bodies, arms and legs – just a few darker tones here and there.

6 To ground the figures, paint some sand colour below and add cast shadows from the bodies, again remembering the direction of the light.

1 For distant figures, paint a 'Y' for the legs and a 'P' for the body. The head is a point.

2 Paint two points for the heads and block in two Ps for the bodies.

3 Now add the Ys for the legs and fill them in. A quick sweep of the brush gives you the ground.

4 Paint a square for the dog's body, a smaller one for the head and two sticks for the legs.

5 Add a curved line for the dog's tail, and there you are – a couple and their dog out for a walk. Now that wasn't hard, was it?

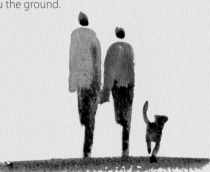

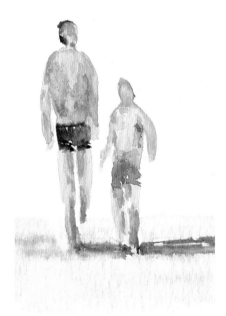

7 If the sun is strong, as is likely since these figures are wearing swimming trunks on a beach, the shadows can be quite dark and hard-edged.

Clothed figures

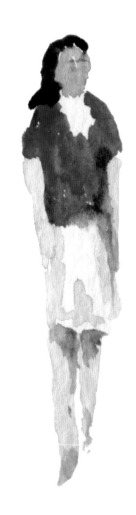

1 Use a No. 8 round brush to paint in a mix of ultramarine and burnt sienna for the hair, then quickly add the flesh tone from the previous pages for the head, arms and legs.

2 When thie washes have dried, use cobalt blue for the top, leaving white paper below the head for white fabric.

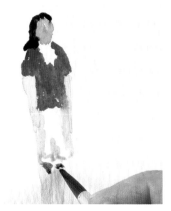

3 On a white skirt, all you'll see is the shadows. Use a diluted mix of cobalt blue and burnt sienna to add these.

4 Make up a very watery version of the mix for the hair, and put in the shadows cast from the skirt on to the legs.

5 Add a couple of marks of the same mix for the features and other shadows, and the figure's done. This isn't a close-up, so a little suggestion is all you need.

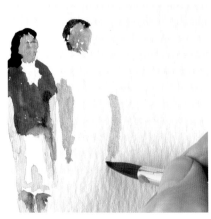

1 Start in the same way for the male figure – hair, head and arms at this stage.

2 Add the jeans with a mid-strength mix of ultramarine and burnt sienna, suggesting the contours of the legs with a slightly stronger wash.

3 Most of the T-shirt can stay as white paper – use the same mix as for the skirt to add a few shadows.

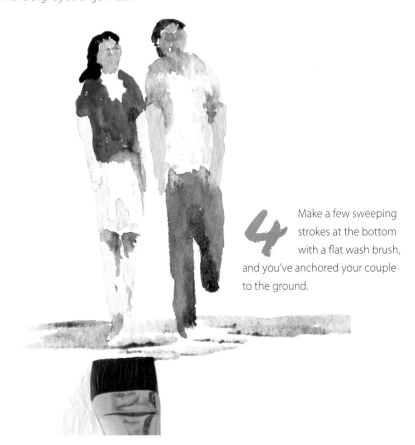

4 Make a few sweeping strokes at the bottom with a flat wash brush, and you've anchored your couple to the ground.

SUNDAY PAINTING

This group is enjoying a bit of shade in the square of a little market town in Tuscany – you'll find that in a grouping, an odd number of people makes a better composition than an even number (the same is true of birds in the sky), so I've painted three figures here, with the left-hand woman partly hidden by the trees.

raw sienna

ultramarine

burnt sienna

Hooker's green

alizarin crimson

yellow ochre

raw umber

light red

cobalt blue

cadmium red

cadmium yellow

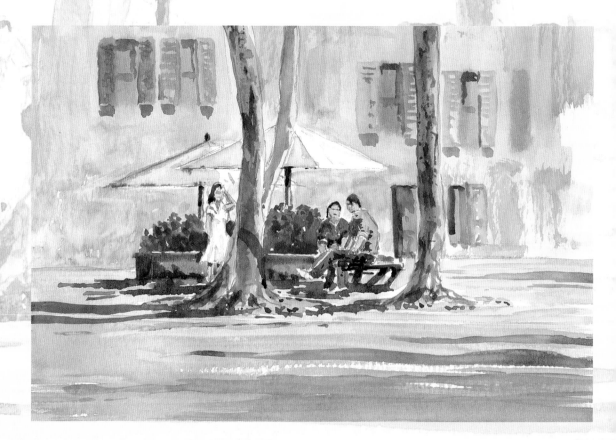

Preliminary drawing

Even in this last project I've kept the drawing to simple outlines; on the people you can see where the hair is and where the T-shirts and the skirt begin and end – but beyond that, the watercolours do the work for you.

Step 1

Use a 19mm (¾in) wash brush to lay on a flat wash of raw sienna for the background walls. This wash is broken up by the trees and umbrella sunshades, so you don't have to work too quickly – don't dawdle, though.

Step 2

Let the wash dry, then put in a rough impression of the windows, using a mix of ultramarine and burnt sienna and a No. 8 round brush. The shutters are Hooker's green, and you need only add a few horizontal and vertical marks. When the windows have dried a little, add a darker mix for the recesses, and use alizarin crimson for the shadows cast by the shutters on the wall.

Step 3

Start the trees with a strong wash of yellow ochre on the right side, where the sun hits the trunks. While this is wet add raw umber, letting it run into the ochre and blending for a soft, rounded edge. Quickly follow this with a mix of ultramarine and alizarin crimson for a warm shadow colour, and flick a few dots of this into the ochre to give texture.

Step 4

Use a lighter wash of ultramarine and alizarin crimson for the shadows on the white sunshades – lighter because they are white and further away than the trees. Paint the posts beneath with a mix of burnt sienna and raw umber, then add a strong shadow mix on the left of the posts – this may be a bit fiddly, but it's a detail that gives a lot of depth.

Step 5

For the flowers drop in a mix of yellow ochre and a little Hooker's green, leaving some white paper for highlights. Dab and dot a mix of Hooker's green and light red into this, followed by a little cobalt blue, allowing the first wash to remain visible in some parts.

Step 6

Loosely dab on some light red for the terracotta plant holders, working around the people. Using the side of a No. 3 rigger brush, put a little more texture into the trees with a dark shadow mix, then do the same up the sides of the huldings and at the base of the plant holders using the No. 8 brush and a watery mix of cobalt blue and alizarin crimson. Finish the flowers with a few blobs of cadmium red while these washes are drying.

FIGURES 117

Step 7

As this is an Italian scene, I've given all the figures dark hair. Make up a very dark mix of ultramarine and burnt sienna and dab in the hair – use the No. 8 rather than the rigger, as you're just giving an impression.

Step 8

The clothes are next – cobalt blue for the right-hand shirt, and a mix of cadmium red and cadmium yellow for the central one. Use darker and lighter mixes of ultramarine and burnt sienna for the trousers, and allow to dry.

Step 9

Paint the faces with a mix of yellow ochre, alizarin crimson and a touch of ultramarine, then move on to the arms and the legs of the woman on the left. Let this dry completely, then drop in a few shadows for the features with a watery, light shadow mix – just a few spots here and there. Use the same colour for the shadows on the dress, going darker towards the bottom, and on the men's clothes. When dry, use raw umber and burnt sienna for the bench, and add some dark cast shadows beneath it and at the bases of the trees.

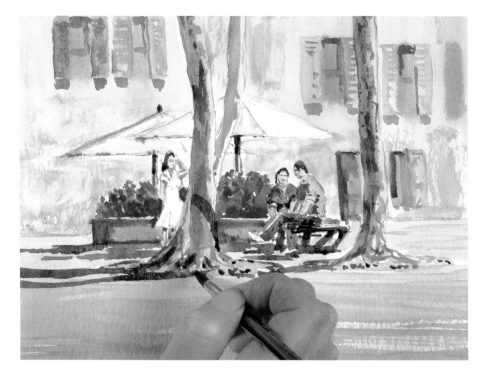

Step 10

To fill in the ground use the smaller wash brush with a watery mix of yellow ochre and light red; start at the base of the building and increase the mix strength as you come forward. Once again, leave a little white paper showing through. Let this dry completely, then use the No. 8 brush to put in the shadows on the ground with a mix of cobalt blue, alizarin crimson and burnt sienna. Don't make the shadows cast by the figures or the bench too long, or they will not be grounded. Put a few blobs at the bases of the trees, then add the shadows themselves. Finally invent something out of view and bring its shadows across the foreground. Now isn't that something to have done!

INDEX